Infallible, In Search of the Real George Eliot

INFALLIBLE
IN SEARCH
OF THE REAL
GEORGE ELIOT

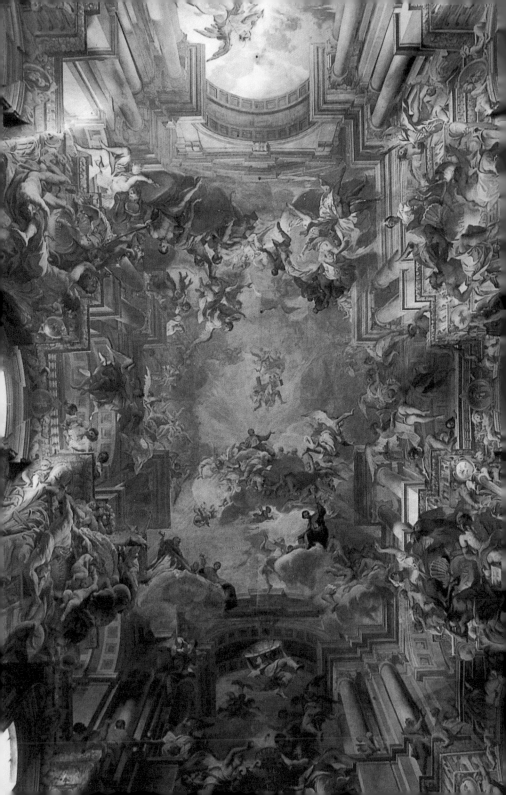

Introduction
ROXY WALSH

Andrea Pozzo's trompe l'oeil ceiling in the Jesu church in Rome is a fabulously transparent visual fiction. It is an optical illusion that has a single effective point of view: its fallibility illustrates the necessity, or at least the benefits, of faithful obedience. Papal Infallibility was decreed at the first Vatican Council as the 19th century drew to a close and modernism gathered speed. As the voice of God on Earth was personified, George Eliot was already in print. Proust wrote his notes on George Eliot in the early years of the 20th century: as concise in his admiration for her as he was expansive in his Search for Lost Time.

Infallible, In Search of the Real George Eliot is a project exploring aspects of fiction in contemporary art. These stories and texts have been written in response to a series of exhibitions and a website. The exhibitions included video, sculpture, painting, drawing, photography and text. The illustrations in this book are not necessarily of works that were in the exhibitions, but are by the same artists.

Every day intellect becomes less important to me.
Proust, Contre St. Beuve.

LOTTERY FUNDED

APT Gallery, London, 26 April – 25 May 2003
Mead Gallery, Warwick Arts Centre, 27 September – 5 December 2003
Huddersfield Art Gallery, 24 April – 2 July 2004
Hatton Gallery, Newcastle upon Tyne, 14 January – 12 March 2005

www.infallible.org.uk

curator and editor Roxy Walsh
designer Jaakko Tuomivaara O-SB Design
art director Ruth Blacksell O-SB Design
printer die Keure, Brugge, Belgium

ISBN 1 873352 83 2

published by
ARTicle Press, University of Central England,
Margaret Street, Birmingham B3 3BX
t: +44 (0) 121 331 5978, f: +44 (0) 121 331 6970

distributed by
Central Books, 99 Wallis Road, London E9 5LN
t: +44 (0) 845 458 9911, f: +44 (0) 845 458 9912
orders@centralbooks.com, www.centralbooks.co.uk

A · H · R · B
arts and humanities research board

UNIVERSITY OF
NEWCASTLE

mead gallery
warwick arts centre

UCE
Birmingham

◆ huddersfield art gallery

Contents

Rules of The Shop (to be opened in the future by Linda and Tegan Aloysius)

1. We will open and close the shop whenever it feels right for us to do so.

2. We will only sell what we feel like selling at a given time. For example, if we feel like selling only air (at a particular time) we will sell only air.

3. We will only sell things if we are both in agreement that, at the time of sale, they are to be sold. If either partner is absent (see Rule No. 6 below) the working partner must take your details and will contact you at a later time (after speaking with the other partner) to tell you if you are allowed to buy the item or not.

4. We reserve the right to enter into any discussions about the items for sale (or about you, the buyer) for as long as we like and in a location of our own choice. If this means closing the shop, so be it.

5. We reserve the right to refuse to sell you something if we believe that you are not suited for one another.

6. If one of us feels like opening the shop and the other does not, we will use an inflatable, life size copy of the other partner until the time that the real partner is in the mood to be in the shop again. The absent partner will inflate their own "self" and deflate their own "self" at the opening and closing of business. The working partner cannot be held responsible for any punctures that occur.

7. We will only accept returned items if you give a reason for the return that makes both of us laugh, to a degree that we find acceptable.

8. We reserve the right to give things away whenever and to whomever we like.

9. We will always make up prices depending on how much we think we like you.

10. If we are undecided on how much we think we like you, we will ask for your contact details and will contact you, at a time that suits us, regarding the sale of an item. We cannot give an indication of when this time of contact may be.

11. If we later change our minds about how much we thought we liked you, and feel that the wrong price has therefore been charged, we will display in our shop window a detailed description of you, your purchase and our wish to contact you. If you do not come forward, and later attempt to re-enter the shop for the purposes of making a new purchase, we will throw you out.

12. We reserve the right to throw you out of the shop at any time without having to tell you why. We may throw you out in any manner that we please.

13. We will display details, each time the shop opens, of what we have done with our profits (your money) from the previous opening time. Any further enquiries about this should be addressed to us directly. The subsequent conversations will be tape recorded and offered for sale. You may purchase a copy of your own conversation with us should you wish to do so. In accordance with our rules of sale, we will then display what we have done with the proceeds of this sale. You may enquire about this again, be tape recorded again and have your conversation with us sold to you again for as many times as you like.

We reserve the right to change these rules without prior notice and at any time.

These are the rules to date.*

Signed.. Date 13 . 04 . 02
 Linda Aloysius

Signed.. Date 13 . 4 . 02
 Tegan Aloysius

* Copies of Rules of The Shop are available for sale from today. Please apply to Linda and Tegan Aloysius in person. All sales of copies of Rules of The Shop are subject to and in accordance with Rules of The Shop.

Gwendolen's Flight

LISA APPIGNANESI

The pale earth was crusty with pebbles. The path rose, a little steep for her heeled shoes. Their passage grated in the silence. But each forced step seemed to give her more substance. She rearranged her cloak to mask the image she had cut from the panel. She didn't want to seem *exceptional*. Out of place. And she was determined. She had already come so far. The picture was for no one but George.

'Exceptional'. That was the word *she* had used to trap her in. *'She rejoiced to feel herself exceptional...'* It was a tease. An Olympian barb. Intended to smite her. To convey its opposite.

The sun shone despite her mood. Clear and bright above the park on the hill and its neighbouring cemetery. The glossy vegetation danced with light. Green, like her dress, which shimmered. Green, like those emeralds, once pawned, forever returned.

Bramble and ivy and vines crept everywhere. Dropping from inordinate heights onto unkempt stone. Lichen-mottled. Crumbling. Returning to earth. The names on the tombs had grown faint, becoming hieroglyphs in search of interpreters. Inscriptions could only murmur a feeble chant to the passage of time. But the vegetation was securely rooted. A wet forest smell exuded from it. She breathed it in and saw the wall of dappled leaf ahead. A bird thrashed from its midst. She was coming close.

The air was cold here. Three monuments rose one after another from the incline. She peered and read. Not the first substantial square of roseate stone which housed a family, but the second. It climbed and climbed, a sheer, smooth expanse of spire, an Egyptian obelisk, stark and godless against the greenery. Its high polish made the reading easier, despite the coil of vine and the sudden colour of pink primulas erupting from its base. Primulas. Like a genteel romance planted by some admirer. Or a stray wind.

George had damned her with that 'genteel romance', had granted her exceptional stature only to snatch it away. No good, it seemed, was ever to be allowed to be altogether hers. *'She rejoiced to feel herself exceptional, but her horizon was that of the genteel romance.'* That's what she had written about her, condemning her to a perpetuity of bluestocking snickers.

No more. She had torn herself away from the sentence and got here. Torn herself out of all their imaginings. Finally. She allowed herself to smile at the irony of the pale, fluttering, primulas on her oh so serious maker's tomb. Smiled still, as she placed the picture of the upturned dead face next to them.

The smile was secret. Her attention was all on the stone, not on the man half- hidden behind it who had, until her appearance, himself been engaged in urging stone to speak.

'Was she beautiful or not beautiful?' he wondered as he looked. And what was the secret of form or expression which gave the dynamic quality to her glance?

She was cleaning away scraps of earth with a tapering finger, delicately gloved, so that the writing came clear.

HERE LIES THE BODY

of

'GEORGE ELIOT'

MARY ANN CROSS

George was the name she knew her by. The name the world knew. Not Mary Ann. Not that latter-day acquisition of Cross which made a respectable woman of her. Had she asked to have that name on her grave? Or was it his idea, the late suitor, so young he had set the gossips' tongues wagging? She had donned a frivolity of headgear for him, though it sat badly with her solemnity of face, let alone her age. What it was that had prompted his plunge into the Venice canal, was fodder for speculation. But at least and at last, she was officially married, not merely partnered. That respectability had come late for George, just a year before her death. Too late, perhaps. Though evidently she had wanted it.

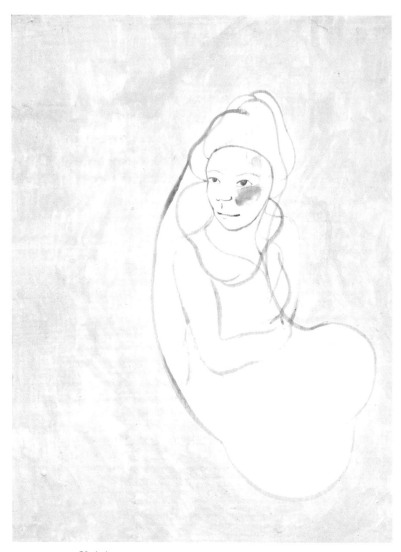

ROXY WALSH *Christine*

Why was it that in her own case, even marriage had failed to confer respectability? *Poor Gwendolen.* That's what she called her. Not that she could have meant it with any sympathy. After all, George had made her 'poor',

lorded it over her creation and loaded the dice from the very beginning. *Les jeux sont faits.* And Gwendolen was doomed. Doomed by her maker.

Doomed but not dead. Instead, it was George who lay here, 'dead in body'. While Gwendolen went round and round, eternally young, a sylph, *a Nereid in sea-green robes and silver ornaments, with a pale sea-green feather fastened in silver falling backward over her green hat and light-brown hair.* Gwendolen Harleth.

Gwendolen Harlot, George might as well have written, given the way she had treated her. A harlot *with both too much and too little mental power and dignity to make herself exceptional.*

Oh, how the readers had argued across the course of the years, more than a century of them. Argued and written and prodded and analysed and distilled her essence, kept her going round and round in a maze of meanings, good and evil, narcissist, lamia, dangerous, desiring, cold, unfeeling, selfish, round and round and always, in comparison to her creator, just 'Poor Gwendolen'. But Gwendolen had been kept alive by their contention, ever beautiful and alive. While George… George just lay there, her body extinguished. It was right to return the panel to her. Now that Gwendolen had escaped, the ghoulish painted face no longer had the power to haunt.

The sound of a voice reading the words inscribed on the tomb made her jump back.

> "Of those immortal dead who live again
> In minds made better by their presence"

"So sorry. Did I startle you?" The hand was quick to settle on her arm to steady her. She was quick to shake it off.

"Are you an admirer?"

She didn't respond, simply gave him her cool gaze.

"Silly question. Obviously you are. You've left her a tribute." He looked down at the dead painted face, his own evidence of its uncertain taste.

"It comes from a house of hers," Gwendolen offered, quite calm.

"I see."

"Do you?"

The man had one of those thin, bony faces which should have been pale from library life, but instead wore a bronzed sheen.

"I'm writing a thesis on James. Henry James…" he said as if it were an answer. As he pronounced the writer's name and met her eyes, embarrassment overcame him, mingled with a touch of scepticism. "You've heard of him, perhaps? He was an admirer of George Eliot's."

Gwendolen hadn't been party to countless classes and tutorials for nothing. "A borrower, I'd say. Even if he did judge her ugly. 'Equine' was the word he used, wasn't it? But we know what he meant… He tempered it, a little. 'Equine with a delightful expression.' He was a guest, after all. And she the great Victorian saint."

The man grinned. "Well, no one ever called her beautiful. James, at least, approved. Even approved of her 'partner', as we'd now say, approved of his 'gay cosmopolitanism'. He was one of the few. Lewes is buried just behind here. Did you know?"

Only now did she notice his accent. American. Yes, she knew, though she had never visited before. Knew so much now. About them both. George and George. About all the books. All the friends and enemies. She had come to suspect that Lewes, the old rake, would have given 'poor Gwendolen' a different destiny, if he'd had half a chance. But he never interfered when Marian was George.

Had Gwendolen had the choice, she would have changed her name too, and not to her husband's. Grandcourt. But only popes and priests and authors could change their names, apart from wives, without anyone batting an eye. And criminals, perhaps. George had made her into half a criminal. Stacked the cards, so some even suspected she had helped Grandcourt to his watery end, rather than simply standing by. Bad enough in George's book, whatever her one-time husband's indolent cruelty.

"Why did her maker so want to punish her?"

The American had misread her silence. Thick eyebrows gathered in a peak. "I didn't mean 'gay' in our sense. James might have been, of course.

Though I suspect he was one of those who'd repressed his sexuality for so long, he couldn't remember his orientation."

He was waiting for her to laugh. Instead, she gave him the languid smile that had tantalised Deronda all those years ago and made him want to look again, despite himself. Yes, look again.

Over the maze of interpretation the years had brought, she had begun to suspect that it was for that second look she had been punished. A look that George, when she was all-too-plain Marian, would have coveted.

"Do you know the source of the quotation on her tomb?" Her fellow visitor began to read once more. "Of those immortal dead…"

"It's from a poem she wrote. She wanted to join the choir of the invisible dead, the immortals." Gwendolen quoted:

> Oh, may I join the choir invisible
> Of those immortal dead who live again
> In minds made better by their presence; live
> In pulses stirred to generosity,
> In deeds of daring rectitude, in scorn
> For miserable aims that end with self,
> In thoughts sublime that pierce the night like stars,
> And with their mild persistence urge men's search
> To vaster issues. So to live is heaven:
> To make undying music in the world….

Gwendolen stopped. George had never allowed her to make undying music. That was the rub. What might have saved her, had been taken away from her. Nothing transcendent was to be permitted her. Because of that childhood incident, perhaps. The canary bird. Yes, yes, she had strangled its voice. But everything had been so mixed up back then, with her sisters screaming and her father dying and the ghastly stepfather. The thought of it even now, made her freeze. A paralysis of cold.

Around them, the day had grown suddenly dark. Thick black cloud filled the sky. Leaves and ferns rustled with sudden gusts. Ivy heaved.

"Uh oh. We'd better run. Would you like a coffee? There's a place in the park. Not far."

Gwendolen couldn't move. It was too late, in any event. The sky released a torrent of hail. It battered the ground, flailed the tombs. The world turned white. Had George willed it? Was she still there, her mind so strong that it could force Gwendolen back to the sentence from which she thought she had escaped?

George had been able to make everyone do her bidding, even the composer, Klesmer. He had put Gwendolen roundly in her place. What was it he had said to her, when she had wanted to support the family with her voice and escape Grandcourt? The words had once been indelibly printed in her mind, an ultimate humiliation.

Too old… you will not, at best, achieve more than mediocrity – hard, incessant work, uncertain praise – bread coming slowly, scantily, perhaps not at all – mortifications, people no longer feigning not to see your blunders – glaring insignificance.

The indignity of it. No, art was not for the likes of Gwendolen. 'Poor thing.'

Why wouldn't George allow it? Gwendolen would have worked given half a chance. Worked hard. Instead she was only allowed to look beautiful on the various stages George provided. In tableaux where dead faces reared up at her, in mirrors, in men's eyes. She was allowed to move beautifully on horseback or as she aimed her arrows. Allowed to provide a beautiful object for Grandcourt to desecrate. Or Deronda to judge. That was almost the worst. Because she relished the quality of his attention.

Yes, George had so made her that imagination of the sterner kind seemed beyond her, self-reflection an impossibility. So she deserved nothing but appearance and the dross of romance. Singing… well that was art, that was reserved for Mirah, or for Deronda's mother. For George herself.

And why? Unless it was that George wanted to hoard the talents to herself, certainly not allow them to any woman endowed with youth and beauty. That was it. That was it. She was jealous of her own creation. Jealous of what she had never herself possessed. She had to punish Gwendolen for the

very favours she had bestowed on her. George, too, had her vanity. Hadn't she lied about her age, like any ordinary woman? Taken a year off from the figures etched on her tombstone.

"Come over here. Under the tree. You'll get drenched. Quickly."

Gwendolen at last heard the young man's voice above the storm. She moved to where he gestured her. The tall oak provided a sort of canopy from the pelting hail. The noise was all round them.

"I'm John, by the way. John Hudson… And you?"

"Gwendolen."

"Gwendolen?"

"Yes."

"As in Daniel Deronda?" The American chuckled, then stopped abruptly. "Yes, I can see. You… you look like her. You're beautiful."

"No longer."

He misunderstood her and rushed to reassure.

But she wasn't paying attention. She was thinking of Deronda. He had wanted her. Yes he had. They were kindred souls in so many respects. But George had intervened. She had forced her to Grandcourt. And she had given Deronda, the soulful Mirah, that girlish, suffering echo of his own mother, but one he could tame. That old virago, Alcharisi, wasn't tameable. She would have nothing of him, even if she was his mother. Had sent him clear away. For the sake of her talent.

And for all her boldness, George hadn't allowed the more challenging match, the one which didn't force like to like, the match between herself and Deronda. She had to learn through renunciation. Hadn't she learned enough by then? But youth and beauty were not to be rewarded. She was allowed life, not love… while George went off with her John Cross, a youthful poultice to her wounded vanity.

The hail had turned to rain, thick and pounding. Enough. Enough. She had come to say goodbye to George. She had torn herself out and away and made the journey to her maker's tomb. The dead face she had cut from the panel at Offendene glowed like some Baptist or Holofernes.

She felt free now. Free to live, as she had so long ago promised Deronda she would do. Even free to change her name. The times were right.

A sodden sheet of paper flew past her and came to rest on the upturned head. It clung to it, as if to cover its painted horror. Gwendolen moved to pick it up and saw an image of a vast butterfly. Its velvety eye rimmed with gold looked out at her. With a shiver, she left the creature in its place. Had George called it here?

Beneath the butterfly, a list of names emerged. An exhibition. Artists. Yes, perhaps George had.

"I'm thinking of changing my name," Gwendolen announced to this John, who had taken off streaming glasses, so that his face looked bare, exposed.

"No longer Gwendolen, then. What now?"

She looked down at the flier. The names were running into each other. "I don't know. Maybe Brigitte or Annika or Sara. Or Roxy. Or better still, one of those men's names. Tony or Paul. Maybe even George."

1 + 1 = 1

JORDAN BASEMAN

Patrick Wilkins I went to see the priest and I said to him, "When I was on a life support machine, I suppose clinically you're dead then, aren't you because it's only a machine that's really keeping your body going? You have no heart, you have no lungs, your natural body has no way of keeping going has it?" And I said to him, "While I was on that life support machine I suppose basically I was then dead, for X amount of hours." I said, "You hear lots of people saying, oh, I still get asked, did you go through a tunnel? Did you see this?" and I have to tell them and I say "No, I never remember anything, just blackness, pure blackness " and I said to my priest, "I wonder why I see just, just, just nothing?". I said "Yeah I would assume I was dead" and he said "Well have you ever thought that you didn't see this tunnel and you didn't see this, didn't see…because you already believe?" "People that don't believe maybe they do see these things because God wants to try and get a message to them that there is something there to believe in." He said "But if you saw nothing but you already firmly believe." I said "I do, I never try to persuade anybody else about religion or nothing" and no one, absolutely no one will ever convince me that there isn't a heaven after we leave this earth. They can argue all they want, I know what I (know). I don't think what I think, I know what I know and that night I had absolutely no fear, no dread, in fact I felt quite serene like I don't (know) the anaesthetist was there. I felt quite calm, serene about the whole affair. There was no panic, no fright, no nothing, and when they said, you know, "I'm gonna put a needle in there", I suppose if you didn't believe in anything yeah perhaps that could have been a bit of a fiercer moment but I just held my hand out like that and he put it in and that was it. I never had any second doubts about that. Obviously I didn't know how long it was gonna be before I did come round again, and I never had any second doubts that I wouldn't come

round again, because this serenity that I seemed to feel. There was nothing, there wasn't a voice there saying you will come round, it was just something that seemed to just be in your brain that you were coming round.

I remember one nightmare... these really terrible, dreadful dreams. They were really bad, really, really terrible, but there was always the two, always the two dreams, same dreams all the while, never different ones, never ever different and they went on for a long while after I came out of hospital as well didn't they?

Christine Wilkins Yeah.

Patrick Wilkins It was about that family that used to come walking past our house, the woman and two sons. She would always have a load of shopping bags and he would have his bike and he would have more shopping bags on his handlebars of his bike. And the other one used to sit on his motorbike but push it along with his legs and just past our house there was a sheer drop over this cliff and they used to walk along laughing and joking right up to the edge of the cliff and then just vanish... and then another one was when they used to come up back over the cliff to go wherever they went to do the shopping and then they would turn round and come back and do exactly the same thing again and that went on for weeks and months that dream. And the other one I used to have was this round, round yellow thing that used to lay on the floor, like a carpet and suddenly it'd go up in the air and start whizzing round the ceiling and when it came down it used to have these terrible, vicious, sharp edges on to try to rip you up or cut you up, but you always, as it, when it got so close, you would wake up. But I wonder if this dream with this thing coming down from the ceiling, ready to cut you up had anything to do with the fact that I'd already been cut up in the operation.

But this family that walks off the cliff, that haunted me, they were really bad, bad, bad dreams, you would wake up and you'd be sweating. Whenever they used to come past and they'd be speaking, talking to each other and laughing and joking and they'd still be laughing and joking when they went over the edge of this cliff. And I could never bring myself to understand why would someone laugh and joke when they were going over the edge of a

cliff. Then they'd come back up again and do the repeat performance. Obviously when they came back up again they didn't have any shopping bags then. And this used to go on virtually every night, this dream, I even got a book from the library once, about dreams, and of all the things and the explanation there was in, nothing came anywhere near to this dream that I had.

It was painful, to say the least, but you took a lot of painkillers to numb it. But even with the painkillers it was still, you knew that it had been done. But obviously with something of that size, it's gonna be more uncomfortable than just giving yourself a quick nick while you're shaving in't it? And my chest still aches actually. My chest always seems to permanently ache. Not a bad ache, but you, you always know that there is some, well I say 'we', 'I'. I am always aware there is something been done to my chest, that should never have been done. I'm always really conscious about that. It's nearly, sometimes it's like having, it sounds very crude saying like having somebody else living with you. You know somebody else living inside you. There's somebody there helping me to walk about, helping me to see, but without them being in there I wouldn't be walking about and I wouldn't be seeing. It's not something that's mind-blowing and this is just how it has affected me but I never let it get the better of me.

At one time just a few months after I had my operation and I was home and I felt that…, quite sickly, really sickly about it and it nearly, I nearly became paranoid, about this heart and a lungs that didn't belong to me and I went, it got me that bad I went to the toilet, tried to put my fingers down my throat hoping I would be able to sick them out. It sort of seemed to take over your mind for those few minutes. Then when I got, collected myself together I realised it would be impossible (he laughs) for them to come out any more and if they did then I wouldn't be walking about. But you know, see, that was quite shortly after coming home, within the first, it was within the first three months because I wasn't allowed to drive my car and Christine, I had to rely on her driving me everywhere… (Laughter in the background)

Christine Wilkins and he loves that! (More laughter)

Patrick Wilkins …and I blame that, her driving, on the fault that I was having this…(All laugh). I still can't touch her, can't bear to touch my chest, still won't touch her. I'll look at it but I won't touch it.

And you get good days and you'll get bad days and you'll get really, really bad days, you know when you do feel really awful. But on the whole you get more good days than anything that's without a doubt but you just accept each day as it comes. If today I'm gonna have a good day then I'll have a good day, if tomorrow I have a bad day then it's just one of them things. I did the easy part, Christine did the hard part and I often say, ask myself, if the reverse had of been…in reverse.

Christine Wilkins I wouldn't have had it done, I'm frightened of hospitals.

Patrick Wilkins No but if it had, could I have waited eight or nine hours…

Christine Wilkins I wouldn't have had it done full stop.

(CREDITS ROLL)

Narration by Patrick Wilkins

This project was only made possible because of the kindness +
generosity of Patrick and Christine Wilkins

Production + Post Production Assistants:
Kilgore Trout
Sound Advice
Mary Shelley
James Whale
Studs Terkel
The Clutter Family
Dick Hickock + Perry Smith
Truman Capote
1 + 1 = 1 is dedicated to those who have given the gift of life to others

(FOOTAGE AFTER CREDITS)

Christine Wilkins Jordan, you ain't had a look at Pat's scar…
Jordan Baseman It's way down on my list of questions…
Christine Wilkins I am really proud of his scar you know, But I saw it
better because there was no hair on his chest then (Laughter)
Patrick Wilkins You can just see a few faint marks along there.

transcription of 1 + 1 = 1 by Alison Plumridge

NICKY HIRST *Caterpillar Text*

L'Urbaniste

NICHOLAS BLINCOE

The man on the hotel television explained that his company's success was based solidly on aggressive marketing. "We are pro-active," he said. "What we bring to the table is a competitive edge. Where other firms can charge anything up to £350 per hour, our teams of Ghurkas will safeguard the perimeter of Bhagran airbase, say, for £35 per man hour." The BBC interviewer said, "You object to descriptions of yourself as mercenaries." "Absolutely," the officer replied. "We are risk managers."

Risk management. The other day, I heard a computer programmer describe himself as a risk manager; he protected operating systems against viruses. And once, I even heard an estate agent claim to be a space consultant. All these euphemisms. I know these jobs are unpopular, but... you know... what was the reason for all this obfuscation? It seemed evident that they were trying to avoid being judged on what they did, so they claimed to be doing something else entirely, something more vague.

I was late. I switched off *News 24* and went down to the lobby where the journalist from *Les Inrockuptibles* was waiting to interview me.

"So, what are you trying to do?" he asked. "What is your aim when you create this new book?"

"Give me a break, Gaston. The only job where you absolutely know what you're doing is the Pope. He never has to excuse his decisions, so there's no possibility of self-doubt. For the rest of us, we know that everything we do, we could have done quite differently."

Somehow, even with answers like this, I managed to get through the interview. I must have done something right because when Gaston closed his notebook, he stayed around to sit and chat. "You know when you see a movie," he said. "A French movie. The guy's always sitting in cafés looking around. What's the guy's job, do you think? Nine times out of ten, he is an *urbaniste*."

"A what?"

"You know. He designs cities: an *urbaniste*."

"A town-planner?"

"That's it exactly. And you know that towns do not need planning everyday, so the *urbaniste* always has spare time and a reason to sit outside and watch people. At least, that's what the film director thinks. And, you know, the film director works six weeks a year and the rest of the time sits in cafés and watches people walking around. So he tells himself, this must be kind of what an *urbaniste* might do. He thinks, my job is kind of like an *urbaniste*. Then he insists the lead character in the film is also an *urbaniste*, a man like the director, but not quite. He is playing the director's shadow job."

"Do you think film directors are embarrassed to be film directors?"

"No, I don't think they are embarrassed. But they want the audience to understand the lead character, and they too also need to understand the lead character. Otherwise, where's the film? It's like they say, 'See this guy, you understand what he does and the way he thinks about things? It's clear, no?' The director is just trying to ensure both he and the audience are on the same page."

I understood. Estate agents and mercenaries lie about what they do because they are self-aggrandising and because they do not want to be judged. But directors, no matter how much we might laugh at them – and we were laughing, believe me – they were at least trying to be modest and they wanted to be judged on their work.

I said, "You know, I once had to explain the novel *Middlemarch* to a group of literature students. What's it about – easy, it's about town planning."

"What is it about?"

"It's about town-planning. Hence the name. Middlemarch is a fictitious town."

In the sitcom *Seinfeld*, the character of George Costanza is modelled on the co-creator of the series and the writer of many of the episodes, my old friend Larry David. We tend to speak to each other about once a week, but he had been filming his new series while I was on a promotional tour in Europe, so we had not managed to get it together. When I called him now, he said,

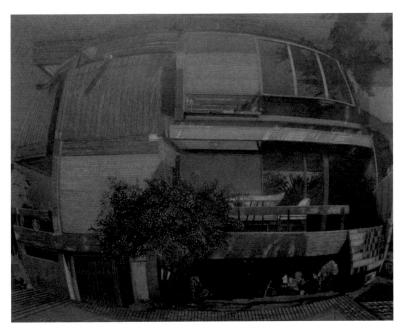

PAUL FLANNERY *Lead Balloon*

"Hey Nicholas," and then to someone across the room, "It's Nicholas." There was a muffled reply and he said, "The English guy who saved my life in Bali. I told you about that. How? How did he save my life? The natives wanted to sacrifice me to their native gods, but he persuaded them to burn my luggage instead. No! Come on! How do you think he saved my life? I was swimming. I got into trouble and he basically saved my life."

I listened to all of this, the story of his near-drowning experience, patiently waiting for him to get back on the phone. He returned asking, "They want to know if there was any mouth-to-mouth involved?"

"Whatcha tell them, Lah?"

"I'm not telling them anything. I'm speechless. The thought turns my stomach. No offence to you, Nick, you're a good-looking guy."

"Listen, if I ever gave you mouth-to-mouth it's buried so deep in my unconscious, it's irretrievable." I wanted to move out of this three-way

conversation with people I could neither hear nor see. "Listen, Lah," I said. "The reason I called, I was thinking about the way George Costanza always talked about wanting to be an architect. I want to know if architecture is your shadow job."

"What's that, a shadow job?"

"The job that you imagine yourself doing, in order to explain your job to yourself and to your audience. You tell yourself, what do I do? – I draw blueprints and I make structures."

PAUL FLANNERY *Titanic; A Little Tongue and a Lot of Groove*

Larry made a couple of uh-huh noises. "Yeah. I tell you, what I was thinking on *Seinfeld*. It's like I worked for the *Yankees*. I had to put a great season together, but I had to do it from an office. Basically, I was powerless. I was never allowed on the field."

"George Costanza worked for the *Yankees*. He was useless."

"Yeah, and now I'm on the field playing Larry David in a Larry David show. I'm trying to hit every ball out of the stadium."

As I spoke to Larry, Gaston was mouthing questions at me: *is that the real Larry David?* So now I had another three-way conversation on my hands.

Larry said, "Have you noticed recently, all these films cut up into chapters, so the writers must think they are novelists. Or puppeteers, that's another motif I've seen around. The screenwriter as puppet-master. They

wish. Ventriloquists even. Have you ever wondered what a ventriloquist's shadow job might be? They spend the night with their hand up the ass of a smaller guy, they've really got some explaining to do."

After the phone call, and after Gaston had left, I found myself still thinking. There must have been a time when artists – which is, broadly, what we are: me, Larry David, and even ventriloquist and *urbaniste* film-directors – when artists were clear about what they did. What do you do? Write rhyming, metrical verse; paint life-like pictures of Gospel scenes; compose melodic, harmonic and rhythmic pieces of music for strings. Now we all see ourselves as something, or somebody, else. Except for the Pope. We have shadow jobs, but his is the shadow job: he deputises for God.

'So what's my shadow job,' I wondered.

It was then I got another call, though when I checked my mobile it was silent. It took another few bars of ringtone before I realised I had put my second mobile in my bag out of habit. I snapped it open and a barely familiar voice said, "Nicholas? How are you, sweetie?"

"Hi there," I said. "Look, I'm in Paris. I'm sorry I won't be able to make any date."

"I know you're in Paris. Tatiana told me. And the glorious thing is, I'm in Paris, too. So what say we make a date now? I'm in the *George V* and I'm wearing nothing but high heels and moisture."

"That would be great, Vivian." I had her name by now. "But I don't have the mobile card swipe with me. This is going to have to be a strictly cash transaction."

"That's fine, sweetie. As long as you accept euros, I want you to come up and turn a trick for mummy."

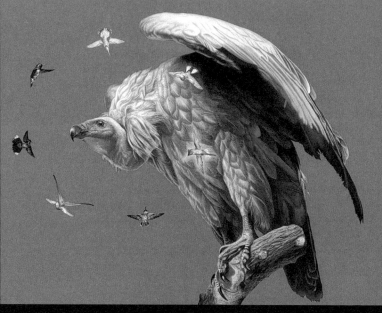

MARK FAIRNINGTON *Vulture Surrounded by Hummingbirds*

Confessions of a Thirteen-Year-Old Killer

JON CAIRNS

The copper was in *their* house, standing on *their* living room carpet, his skinny wrists sticking out of his stiff uniform. Kev had to make him seem awkward and ridiculous, to attenuate his presence in the family home, maybe to make him seem less alien, which of course he was: Kev had never been in trouble before.

He nodded in the direction of the framed drawings of animals hanging on the walls. "Did you do these?" Kev nodded in return. He'd copied them from his many books on nature: African mammals, an *Octopus* edition on birds of prey.

The policeman lectured some platitudes about Kev having a talent and to be careful not to throw it away and asked whether he was doing well at school. He'd come round to check up on family circumstances, get a handle on the home-life. Perhaps the pictures on the living room wall were a sort of relief to him, Kev thought, symbolic of how Kev was valued – he could see that, after all, the boy wasn't some wayward weird kid from a dysfunctional family, just wayward and weird on his own account. Maybe he saw an adolescent boy with too much time and surplus imagination on his hands. A boy with too little perspective to envisage his own future trajectory beyond a vague shifting from a youthful desire to be the next David Attenborough to concentrating on visual art. Kev was content to be absorbed in the immediate pleasures of minutiae. He submitted hours of his time to each wrinkle in a black rhino's haunch, to every feather glossing the back of a bald eagle or peregrine falcon.

He would scan the genealogies of canonical history (every date for every king and queen committed to futile memory); he invented intricate parallel worlds (a whole country, with a colonial past, revolutionary succession, the works – even a new language). In more sinister moments, a rusted grave

marker in the local churchyard, its words illegible, became the proof of a dead older sibling and a perfect way to make the hairs tingle on the back of his younger sister's neck.

One thing became another: it was so easy, so tempting…

*

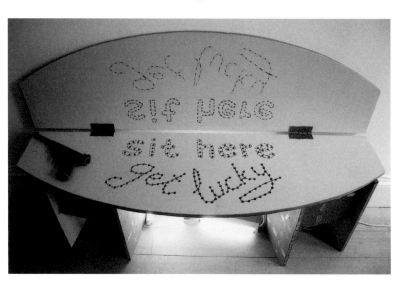

ARTLAB, CHARLOTTE CULLINAN + JEANINE RICHARDS *Sit Here, Get Lucky (bench)*

Sandra Corby. I can't get her out of my head. She crept up on me in the gallery in Huddersfield, bringing with her a whole raft of reminiscences, not all of which I relish. I thought I'd forgotten about her, or, rather, I'd like to forget about her but she keeps tapping me on the shoulder and making me turn around. Her ghost has been lurking for nigh on twenty-five years, but there are times when she becomes a little less translucent than I'd prefer. You see, she's more than a fictive conceit, although she's that too. I made her up, but she became a liability and I had to dispose of her.

The show is full of references to somebody else living inside you, palimpsests of other body forms visible within the main outline. How could I not be reminded of Sandra here? A scrappy oil sketch of a woman and

child could be a portrait of her, with her happy-face smile and the kid's head that looks like a skull – a corny presage of her end.

I ponder another piece, am captivated by its lapidary surface, am snared by her again. I remember my own adolescent penchant for making painstakingly detailed renditions of various zoological specimens, which my father would whisk off and proudly frame. I only ever chose those deemed handsome or majestic or pretty enough to warrant artistic attention (after all, David Shepherd never did pigeons, or woodlice. A leaping lynx was far more fitting). Ms Corby inveigles her way into my thoughts: my remembered aesthetic meticulousness brings back to me how I concocted her character, the myriad little embellishments to her story, my absorption in the colourful drama unfolding about her, enfolding me.

<p style="text-align:center">*</p>

The visit was a reciprocal one: it only came after Kev himself had been forced to go to the village policeman with his confession, itself brought on by the discovery of his elaborate hoax. He had transformed himself, becoming older, swapping his gender, changing his voice. Not quite Norman Bates, but he was trying (the birds were there, although wrought in ink, not stuffed). The poor village plod had seemed baffled, couldn't quite believe that this slight kid who looked younger than he was had done it all himself.

Kev had always enthusiastically led the other local kids, including his sister, in hanging about the one phone box at the bottom of their estate. At first the usual pranks to mess around with the operator ("get off the line, there's a train coming!"); but graduating to telegram messages and impersonated voices to cause confusion at the victim's end and much hilarity at theirs. But rather than leave it at such a juvenile level, he hankered to take the whole thing that bit further.

The joke calls had started small, but, with the collusion of the other kids, got more daring as the excitement surged. The initial idea for Sandra Corby took shape quite quickly: a long-lost school pal seeking to reconnect with her past. The details emerged more gradually over the bored weeks of the

summer break. Sandra would get in touch with Joan Mackey, a local woman he knew. She would be overjoyed at having tracked down a fondly remembered childhood in the North-East. Sandra would be the perfect conduit for feeding back everything that Kev knew about Mrs Mackey in his effort to make her as compelling as any real woman. What better way to cement her authenticity than to entwine her in the other's history? He would use all the information gleaned and stored from years of friendship with her youngest son: her maiden name, where she'd gone to school – a crucial fact, because of course, Sandra had gone there too. Telephone numbers, addresses, he already had those. He would fill her in on all the missing years, provide the life story. And all in character, including a middle-aged woman's voice.

<p align="center">*</p>

In the gallery a video comically improvises a sadistic routine – it's all in jest, no real harm is meant. Sandra had meant no harm either: she was a game, an innocent invention. My imagination had needed the exercise – the whole thing was a charade, which should have ended much sooner than it did, but for my addiction to the mundane power exerted by make-believe. I never thought about consequences until they confronted me. Nothing was calculated, except in the most rudimentary way. The men in the video veer between mock inquisition and sly enjoyment of inflicting abuse on one another. I expect they'd only sketched out a few rough parameters for their actions and left the rest to the moment. In retrospect, Sandra Corby did not appear fully fledged – much about her was improvisational, contingent on the circumstances in which she found herself, even the biographical facts arrived *ad hoc*, committed to an already well-honed trivia memory as they spilled out in her telephone conversations, rather than set out in advance. Who, then, was she? What was her *raison d'être*? Looking back now, I can speculate freely. Was she a channel for surplus creative energy? The queer embodiment of an as yet unformed subjectivity? Was she more than just a routine, a vehicle to see how far I could go in fooling someone?

The story began to nuance, its events were becoming more complex. To off-set any alarms ringing from the background noise of kids giggling round a public call box, he moved to the dubious comfort and privacy of his parents' hallway. Shifting buttocks on the leatherette seat of a fake-veneer phone table

SARA MACKILLOP *Jigsaw; 7 Jigsaws, white*

at the foot of the stairs, he added yet more to the tale. His mother must have been out, dad at work – he didn't want to risk getting caught. Compelled by the thrill of ventriloquy, he reeled off yet more details, coaxing out the same in response from Mrs Mackey. Of course, in the days before website reunions (it was 1980), this was all rather uncommon. Cilla hadn't yet made it standard TV fare. Perhaps the odd feature on *That's Life* would tearfully re-join parted family members (was that where he'd got the idea from?). Mrs Mackey, unsurprisingly, had no recollection – but maybe Sandra could con-vince her otherwise. Tragedy was interwoven where appropriate, but kept in check by a more prosaic account of two husbands (one dead: cancer), grown-up children with each, life away from her childhood home (she'd moved South early on), a part-time job in a prison library.

He performed her so well he began to convince himself of her presence, began to forget the limitations of fiction. He sent a letter, in Sandra's own hand, confirming a plan – already tentatively agreed over the phone – to

meet up. She looked forward to seeing her former classmate again after – was it nearly *forty* years?

A filched photo of a family friend was enclosed, standing in for Sandra (Joan would need to recognise her when they met). Unwisely, also an address, so that Sandra could receive Joan's correspondence (to be intercepted by a conspiring cousin). He never once thought that Mrs Mackey would turn up at the address he'd so ingeniously supplied, had never imagined she would have any cause to doubt Sandra's honesty. As long as one person believes it, no story is untrue, as Paul Auster has said. Kev was unaware that *he* was that one person.

When his mother got wind of Mrs Mackey's bewildered search for the elusive Sandra, she asked him quietly whether he had anything to do with it. "No," he replied, sheepishly looking up from his homework. This galvanised him: he had come to an impasse in his narrative and needed to find closure, not only to evade his own capture, but to resolve the impending collision of fantasy and reality. Sandra was already on the motorway, driving up for the arranged rendezvous. He knew it had to come to an end somehow. But while he was worried about being discovered, he couldn't weakly pull over and let the engine simper to a halt in the face of mere maternal suspicion. Sandra was in motion, hurtling towards an impossible conclusion. How could he stop her?

DEAR JOAN

REGRET TO INFORM YOU THAT SANDRA HAS DIED AFTER INJURIES SUSTAINED IN A ROAD ACCIDENT ON THE A1

A. HALL

He killed her off: what tidier resolution could there be? The narrative conventions demanded it. He was only following the rules. What's more puzzling is the medium in which he chose to do it. He killed her with something as arcane as a telegram. The system is surely defunct today, but even

then it was scarcely used. It had a whiff of romance, an appeal derived from films he'd seen, or period TV drama. Kitschy now.

<p style="text-align:center">*</p>

There are CGI forms morphing on a monitor. If I'd had a computer back then I'm sure Sandra Corby would have had an email address. The voices in the headset tell me about the virus as metaphorical discourse. I wonder whether Sandra was a virus – she had managed to infiltrate family defences, disrupt Joan Mackey's domestic peace.

I move to another piece, and find myself listening to the endless woes of a talking brogue, projected on to a screen on the gallery wall. Each misfortune it recounts is great enough to suffice on its own, but another tragic event occurs, and still another, in an excessive accumulation that forces a black smile. For Sandra Corby too, the melodramatic finale on the dual carriageway wasn't the last of it. While she had come to a crashing halt, I was driven on, dissatisfied with the incomplete narrative arc.

<p style="text-align:center">*</p>

So, another letter, handwritten, slanting the opposite way this time, indexing the grief of her widowed husband (a man who went by the entertainingly naïve name of Albert Hall). There were even fabricated tear-stains smudging some of the words as he wrote of his regret that Sandra was never able to fulfil her desire to see Joan again.

His mother was waiting for him when he came home from school, in her hand the trial run of the letter, guilelessly left in his waste paper basket. The shock of her rage and the cataclysm of his unveiling sapped any lingering feelings of triumph over having duped everyone, having 'gotten away with it'. But his final humiliation was yet to come – a direct apology to Mrs Mackey on her doorstep, sobbed through snot and shame. She was dumbfounded with incredulity – that it had been him! That he had done it at all! She had been wholly convinced by the voice, if not the content of what it

uttered, had assumed the hoaxer to be an adult. Baffled and suspicious, Mrs Mackey had passed everything on to the police.

The caution at the district station was nothing compared to the doorstep confession. On his dad's advice he thought about something else while the sergeant tried to scare him with stories of what would happen to him if he didn't straighten himself out. Lucky for him she hadn't pressed charges. The sergeant would have had him up in front of a juvenile court. He'd have had to tell his fucked up little story to all and sundry.

<div align="center">★</div>

He went back to eagle owls for a while before discovering a knack for pastel portraiture.

LE ECOLE DE BURROWS ET BOB SMITH

ENOUGH SWAN 4 ALL

THE DIRECTORS OF THE ART SCHOOL, BURROWS ET BOB SMITH, HOSTING A THREE COURSE DINNER IN THE SCHOOL'S TWO STAR RESTAURANT, IN PROTEST AGAINST ENGLISH LAW WHICH GRANTS THE QUEEN OF ENGALAND THE SOLE RIGHT AND ENJOYMENT OF THE EATING OF SWAN MEAT. A FEAST OF SAWN PATE, ROAST SWAN AND SWAN TRUFFLES WERE SERVED FOR ONE AND ALL.

Apple

JULIA DARLING

1. Joey

Joey is a tree surgeon. He spends his days trimming the wilder branches of trees in a whir of sawdust. Of course he thinks about his mother, but the loud scream of the chain saw helps to drown these thoughts out. It's harder for Joey when he is on the ground, in a café, for example, when apple pie is on the menu, or walking past a greengrocers with a pile of glossy red apples outside. Sometimes Joey is haunted by the smell of apples.

2. Andrew

Andrew would like to smell of the English apples that he grows in his orchard, but mostly he smells of lemon flavoured disinfectant, as he is a cleaner.

He arrives at a red brick building at 6.30 am and goes to the basement where he opens a metal locker. Inside there is an overall and a brush, a mop and a tin bucket with a mop squeezing device fixed to it, dusters and polish. Andrew puts on his overall which is light blue cotton. He buttons it up. Then he starts on corridor one. Andrew has a key that opens all the offices on the corridor. He steps into each one, smelling the aroma of each occupant, sweat, paper, perfume, and he empties the waste paper basket into a black plastic bag. He swishes around with a duster and mops the lino floor with disinfectant. It smells mouldy, like dish clothes.

Andrew doesn't see the people who work in the offices. He cleans up their footprints, their sweet wrappers, their apple cores and nail clippings. They leave their thoughts scattered about like dust.

On the third floor there is a room of computers, a maze of grey faces all looking in the same direction. They smell of the inside of a pencil case with wires trailing downwards, each one guarding its electricity supply. He runs

his duster over the keys. Andrew looks up and sees the shadow of Mr Potts walking down the corridor.

Mr Potts is the head of all the office cleaners. He was once in the army. He is very clear about the rules. *You mustn't smoke whilst cleaning. You mustn't look at anything confidential. You mustn't clean too much or too little. You have regular hours and you stick to them.*

He sticks his head around the door and smiles at Andrew.

"Thanks for the apples," he says. He holds up a ripe apple, bites into it.

Andrew says "You're welcome."

3. Mr Potts

Andrew is very polite. He stands in a way that I appreciate. He doesn't slouch. His arms don't wave about. He is a good cleaner. He cleans in a precise, unemotional way, and that is an important skill in this business. After I left the army I was unsure what to do. I came home to my mother. She lives in a house at the edge of the city, where fields and buildings fray together. Together we waited for something to happen. We ate pies. We watched documentaries. We went to lakes and castles together. But I was restless. I didn't want to worry my mother, but I felt nervous. The army was so regular, and the world outside made me jumpy. You never knew what would happen next. My mother was hoping I would meet someone and marry and have children. She sent me down to the pub, hoping that I would meet a girl, but I never saw one I liked. The truth is, I prefer men. It's taken me a long time to admit the fact I am gay, but I can say it out loud now. I haven't told my mother and I would prefer not to be gay, but I am, and there is nothing I can do about it.

I applied to be a cleaner because I thought it would do as a job for a while. I had no idea how much I would enjoy it. The moment I was introduced to my first mop and bucket I felt at home, and some of my nervousness abated. I love the smell of damp cloths, bleach and polish. They make me feel secure. My employers promoted me, and soon I was head of the team, cleaning a whole estate of white, grey and brown offices,

conducting a chorus of cleaners, emptying nearly five hundred waste-paper baskets a day.

4. Andrew

Before Andrew was a cleaner, he was a doctor called Andrea. She dealt with lungs. She looked at lungs all day. They are very variable, as variable as trees in their scale and personality. Andrea sorted out those with cancers and tuberculosis. She knew the sound of pleurisy and pneumonia, and bronchitis. Andrea still has sensitive ears that can hear a blockage in a tube from miles off. She worked very hard, and of course this was part of the problem. Her brain became overloaded.

One of Andrea's colleagues was called Celia Monroe. She was young, with a face like an intelligent horse, and black shining hair that she wore in a classical style. She was also a poet. She wrote about viscera and body fluid. Her poems were full of tears, saliva, semen and sex. Andrea thought they were very good and said so. Celia's hands were bony, like brittle twigs. Her poetry was similar. Andrea saw her often. She became a friend. One day they were standing together looking at X-rays, when Celia started massaging Andrea's neck.

Celia invited Andrea to her house. She said she was having friends over, and would she like to come, but when she got there she was alone. The house was in a green corner of the city. It had small, spotless windows, and the rooms were full of books and things that hung from the ceiling. She offered Andrea a bowl of olives. Andrea wondered if Celia was trying to seduce her. She wore a black dress that had no seams or fastenings, and even if Andrea was interested in sex, she could never have undone it.

Then Celia said, "Andrea, are you a man or a woman?"

"What?" she said.

"I'm just curious," she said, fiddling with her toes.

So Andrea/Andrew told her the truth, that she was a woman becoming a man.

"I thought so," she said. "I've been watching the hair growing on the back of your hands. You must be taking testosterone?"

"Yes," Andrea said. It was such a relief to have things out in the open. She told Celia about her therapy, her forthcoming operations. Her fears about her son. The divorce. Andrea told her everything. She drank it in, tilting back her head, letting her glossy hair spill over the velvet cushions.

Celia offered Andrea a plate of Parma ham and a glass of red wine.

"Well, Andrea," she said "How amazing."

"I would prefer this conversation to be confidential," said Andrea softly.

Celia yawned, reaching up into the air with her long fingers. "Of course."

5. Celia

Sometimes I think that my boundaries are not so well defined as those of others. They are scrubby and permeable and patched with pallets and old bathtubs like 1976, not neat and picturesque, not up to European standards (dry stone walls, or cut and laid braids, or refined copper beech kept from the mouths of ponies by double layers of barbed wire). I have to be on guard too, not to throw back my head too haughtily, or to sniff the necks of people I don't know well.

Sometimes I think that I'm not suited at all to my work in the hospital: I can't quite judge things. With the lungs and the ribs and the fluids I'm fine, but with colleagues it's harder. I have to pretend that the dribbles don't show, that men have to do what men have to do, that it's polite to gossip but treacherous to tell. I forget that what I know before I am told is not meant to be secret, but that secrets are what you are not meant to know. I am too busy guarding my own.

There was a doctor I liked who smelled of apples, and I would use any excuse to be her friend. I wanted to put my face in his hands and let him stroke my fine ears. I tended instead to the knots in her neck, and knowing I understood, she told me what I already understood. It undid all under-standing, and I told this told secret, and he dessicated, went wild like ripe grass-seed.

ROXY WALSH *Silvertone*

6. Joey

I don't know what to say to my mother. It's just too embarrassing. I don't understand it. I want to go home sometimes, but home is cut down, different. I don't know who I am.

7. Andrew

Why did Celia Monroe behave so badly? I still don't understand. She must have been afraid, or ill, to have been so wicked. She told Dicky and Francis at work, and I was ostracised. They wouldn't look at me. I was aware of laughter and whispering.

I no longer knew which toilet to use.

I had a breakdown. People don't really know what a breakdown is. They imagine ravings and sobbings. I did none of these things. I started to dislike opening doors. I felt quite rational. I would stare at an egg for too long, or keep repeating a word like 'spoon.' I was obsessed with Celia. I read her poems often which gave me a false feeling that I did know her.

I could see how bitter they were. They were full of spit.

Sometimes I would phone her late at night, and listen to her breathing before I hung up.

Then I told my son Joey. He was eighteen. He looked at me for a long time. I could see the blood vessels beneath his skin swelling. His neck reddened. Then his eyes filled with tears.

"I'm sorry," I said.

Joey packed up a rucksack. It struck me that it looked like he was carrying his childhood away with him on his back. "You've killed my mother," he said, then he left the house.

I took early redundancy.

It's hard to know when a breakdown begins, or ends. It has ended, I know that. When I button up my blue overall I know that all is well. An egg is an egg.

8. Mr Potts

Andrew looks very sad sometimes. The life of a cleaner is lonely. You start early and then you're home again when everyone else is getting up. I want to ask him out, but I am afraid. I don't know where to start. I think Andrew lives alone. He has that look about him; an empty bowl, a closed window. I think he has a past, but that's not my business. I also have a past. I have seen some terrible things in the army. Bloody insides. I wish I could tell Andrew.

9. Dicky

Andrew bumps into Dicky from the hospital in a lift. They are inches away from each other. Dicky can see the hair follicles on Andrew's chin. He's wearing a suit. He says, "Hallo Andrea."

"Andrew," says Andrew.

"Of course." Dicky tries to look casual.

"Did you hear about Celia?"

"No."

"TB," he says.

"Ah."

They have reached the roof level of the car park. Andrew steps out. The sun washes over everything.

"Bye." he says. Dicky waves. Then blushes.

It makes sense, thought Andrew. Celia Monroe will lie on her sofa coughing up blood as her lungs collapse.

She will write about it. She had blight.

10. Mr Potts

Andrew appeared, standing in front of my desk with his arms straight and his face polite and pale. Andrew never interrupts me. He listens to everything I say as if he drinks up my words. He's holding a box of windfalls. They are not like the apples that one buys in supermarkets. They are particular, sometimes oddly shaped. They taste of lemons, or spice, or rose petals. They are golden, or a deep glossy red, or a thousand shades of green.

I don't like to eat them too fast. I make them last for weeks. I carry them in my pockets, smelling them, feeling them.

I would like Andrew to invite me to his orchard. I dream about being there with him. But he is a formal man. He doesn't like anyone to get too close. I don't know where he comes from. I don't know anything about his life. But I am a man can wait. I am a soldier, and a soldier has patience. I can sit here, knowing that Andrew is cleaning the office thinking.

He still calls me Mr Potts. My name is Bruce. Next time I see him I will say "Call me Bruce."

11. Joey

My mother was a plain woman. If she had been a tree she would have been a sycamore. I haven't seen her in her men's clothes, but I am sure that she will try to be unobtrusive. Often, when I am walking along the street I think I see her, a grey man in a quiet blue coat, just passing, hardly breathing. I wouldn't recognise her until I went up close and breathed in, for no matter what gender she is, she would still smell of apples.

I am going to read more
poems now

A Few Words About My Poems

MAUREEN FREELY

First let me say how pleased I am to be here, and how honoured I am to have been paired with the illustrious poet we've just heard. He's a hard act to follow. But I'll do my best.

The first poems I'll be reading form a sort of triptych. Each paints its own picture, but the three panels are meant to stand together, rather like those religious paintings of the early Renaissance.

Looming over this particular triptych is a rather remarkable tree that you can see from the M4, just outside Swindon, and that has come to mark for me the beginning of the West Country. Or the end of the West Country, if you're heading in the opposite direction…

It is not in fact a single tree but a copse that stands like a fan at the top of a bare hill. I always mean to check it from the train and I've often wondered why it is that I never remember until we're way past Swindon.

This, in any event, is the train of thought that led me into the first poem in my triptych. I should also add that I was on my way to Heathrow to fly to Phoenix, Arizona, this being my first trip back to the country of my birth since 9/11. You could argue that it's not my home anymore; at least that was the argument that was going on in my head that morning.

I was also thinking about the seriousness, the grim sense of purpose, on all the faces surrounding me on this early morning train. Even though the train was in *reverse formation*. Those of you who are already familiar with my work will probably have experienced a shiver of recognition upon hearing those words, for they eventually found their way onto a rather pretty cover.

(SHOW COVER)

As always, there's a rather complicated story about how it ended up there. But for now all you need to know is that I also used it as the title for the first poem in my triptych. So without more ado…

(CLEAR THROAT)

(ADJUST GLASSES)

(SURVEY THE WHOLE AUDIENCE, FROM LEFT TO RIGHT)

(ENUNCIATE THE TITLE WITH APPROBRIUM, PAUSING BETWEEN THE TWO WORDS)

Reverse Formation

I realise now that I ought to have explained the reference to Ephesus in the second stanza, as some of you must have wondered what it was doing there. Without going into too much detail, let me just explain what I meant by the line 'going against the tide history'. I meant it quite literally – the standard visit to Ephesus beginning as it does at the bottom of the slope where the ancient city's oldest ruins are located, and ending at the top of the slope, where you'll find the city's later monuments. While this makes historical sense, I have often found that starting at the top and going against the tide of history (and tourists) is cooler, easier, and (for the first few centuries at least!) a lot less crowded. And then there's the view, the sublime view. Hard to believe, when you look out over the vast plain, that this was once a seaport...

(SIGH DEEPLY)

But back to my triptych.

(SMILE)

Let us move on to the second panel, which finds us back in the B-car of a five-car Adelante bound for Reading. I don't know if I mentioned that every single women in the B-car, who was anywhere close to my age, had a Nokia phone as ancient as the one my daughters made me trade in after Christmas. I should also mention that the sunlight was sublime that morning. It was more hint than fact, a faint illumination behind the skin of the pale china blue sky... the clouds were not clouds so much as *suggestions* of clouds, hinting rather than hanging over the soft, half-wooded hills...

I hope this clarifies some of the more obscure word-clusters.

It might also help to know that I was trying to write without recourse to metaphor. All the numbers I use are real and not meant to resonate. 7.42 is in fact the time the train left Bath and – fact being stranger *and* crueller than fiction – it really did cost £109 return. You may rest assured, however, that 07768 904678 is not my actual number. I did use the real number in an early version and lived to regret it. So what I've done here is to use a number that bears a geometric relation with my real number while still safeguarding my privacy.

The title of this poem is *Triband*, because that is what my new phone was meant to be. I wasn't sure if it was going to work in the US, though. So many people I knew had taken *Tribands* to the US only to find that communication with the rest of the world proved impossible. Indeed, this was my main anxiety about my impending journey.

I think that's all you need to know, except, perhaps, for the basics of my multi-continental persona. Born you know where, raised on the edge of Asia, domiciled in deepest Wiltshire… 'Yes', I hear you thinking. *Triband*. And yes, you're right. But for reasons that I hope will become clear as the poem unfolds, I'd still like to ask you to resist that metaphor.

(CLEAR THROAT)

(BREATHE IN)

(LOOK AS SAD AND AS LOVELESS AS YOU FEEL)

(SPEAK FROM THE DEPTHS OF THE CHEST)

Triband

And now on to the final panel in my triptych. But first let me read you the notes that gave birth to it. I'm going to read these out cold, without first explaining where they come from, as I feel they would lose their magic if I did.

So here goes. See how these hit you:

Saskatoon. Fargo. Bahia Thunder. Billings. Manaus. The Pas. Grand Forks. Bismarck. Mobridge. Minot. Rio Missouri. Viento de Cara. Big

Horn Mountains. Devil Tower. Pierre. Clark. Pumpkin Butte! Casper. Provo. Moose Jaw…

Moose Jaw!

Isn't that sublime?

I'm sure some of you will recognise many of these names as belonging to a tranche of the American West that stretches from North Dakota to Colorado and beyond, and those of you who have flown recently in a 757 will recognise some of the anomalies in the list as features of that little map you can see on your personal screen if you get tired of watching movies and want to know where you are. They look like toytowns, these maps, don't they?

And you keep on going from a map of the whole world to ever smaller frames and then they tell you how far you are from your point of departure and your destination, and how fast you're going, and how cold the air is outside the plane, and the whole thing is in the oddest mixture of Spanish and English! The ordering of place names doesn't follow any recognisable logic and the whole thing is disconcertingly fluid but somehow evocative of a thing a more courageous person than myself might call home.

And I suppose that – in my way – I'd been thinking quite a bit about home as I sat in that scrunched-in middle seat of that middle row of that 757. A word to the wise – never accept a seat reservation in a 757 if it begins with an 'E!' Home had definitely become an overloaded concept for me by the time we were flying over North Dakota, and not just because I was flying over the country of my birth for the first time in almost three years.

As it happened, I had chosen the wrong film – can you believe it? There was a choice of eight! So where was I? Yes, I'd chosen the wrong film, and given up on it, so instead I was reading Joan Didion's *Where I was From*. This, in case you haven't read it, is an investigation – a very Didionesque investigation – into the confusions and contradictions underlying the Californian dream. The cutting off, cutting loose, don't-look-back mentality. The mourning of the passing of the old California by the very people who benefited from its loss. I looked away from this book to reflect on some point or other and there it was, at the centre of the screen…

Moose Jaw!

And as I watched it, my Didionesque ruminations led me back to the confusions and contradictions of my own upbringing, on another continent.

Oh, how my own mater and pater used to agonise about the tourists who were ruining the Greek islands, ruining the ruins, clogging up the restaurants and filling the hotels! Did they not see that we were tourists too?

It could even be argued that we were the tourists who started the wave. When we first visited the beautiful island of Ios – I won't tell you how old I was, I'm afraid it would date me – there were only six other foreigners there, and I'm talking the whole summer. But today…

You see my point. And on reflection, I think it explains what I was trying to do in this, the final panel of my triptych. Not so much to resist metaphor, but – through the resistance of metaphor – to trace the strange movements of the mind in transit, how it can conjure up visions of Ephesus and Naxos even as one is sitting in the dreaded 'E' seat wedged in between two fat ladies, staring at the toy-town on the little green screen that tells you you're just over a place called

Moose Jaw!

Even as one is engulfed by mass tourism – even as one admits that one is part of the problem – the chicken and the egg problem – and moving inexorably forward, the pull of the past remains.

And the patterns multiply. For throughout this flight, there was a mobile phone somewhere nearby that was playing that dreadful ring tone I had on my first ever mobile for years until my daughters showed me how to change it. I did make an effort to locate the offending owner but stopped after I realised that the man acorss the aisle was sure that offending person was *moi, moi-même, and je.*

I guess that's all I have to say for now, except perhaps to concede that the reference to boxes in the final line is, I must admit, a glancing nod in the direction of a metaphor, but I use it because it was the word that just about summed up my feelings by now. I'm talking eight hours into a ten and a half hour flight, by which time I'm thinking quite intensely about the curious

paradox of lacking legroom at a time when you are actually travelling at 576 mph.

These are the moments when you cease to believe in the land that made you, when all there is in the world is a toy plane over toy mountains divided by the crooked finger of a lake.

(PAUSE)

(CATCH BREATH)

(REMEMBER: THERE ARE SOME LONG LISTS IN THIS ONE, SO
PAUSE WHERE INDICATED)

(SURVEY AUDIENCE, BUT HOPEFULLY THIS TIME)

(SMILE)

The Paradox of Legroom

Thank you, thank you so much. But please, no more applause until the end... I'll die of blushes...

But thanks for smiling. You have no idea how grateful I am...

In fact...

I don't know about you, but I think of these events as ceremonies...

How many of you in this room feel, what with politics going the way is going and there being no certainties, not even the ground beneath our feet, that there are patterns out there, serendipities you could never have imagined?

No?

Well, never mind.

All I can say is that I do.

But moving on...

The next poem is not a piece of freestanding verse so much as a coda. I think I was trying to capture the jolts and fragments of my re-entry into my native land. My aim here was to resist not just metaphor but narrative, that selective monster that leaves all the best bits on the cutting room floor. It's called *Why?* Because that's what the officer for Homeland Security said when I told her how long I'd been gone.

Why indeed?

So anyway, you look for a story here at your peril.

Although for the record I can say that I had a pretty miserable time.

The people who'd invited me wouldn't talk to me so I was pretty much stuck talking to the waiters and the various strays who turned up at the pool bar. These included a woman who ran a gun club, a hotshot lawyer who read at several poetry slams a week under the code name El Pequeno, and a man from Tucson who made mobile phone masts that looked like palm trees.

The margaritas were good though. That is, the ones I remember.

There were also one or two people from our own fair isle, and as serendipity would have it, they are with us today.

The less said about them the better.

So all I'll say now is that I wrote this poem with every molecule in my body.

(ADJUST GLASSES, CLEAR THROAT)

(TAKE OFF GLASSES AND THEN PUT THEM ON FOREHEAD, JUST LIKE YOU-KNOW-WHO DOES WHEN HE'S TRYING TO LOOK PORTENTOUS)

(KEEP THEM THERE UNTIL SOMEONE MAKES THE CONNECTION)

(LOOK GLANCINGLY IN HIS DIRECTION, BUT WITHOUT QUITE MEETING HIS EYES)

Why?

What do you think of my shoes, by the way? Oh good.

Yes, they cost a fortune.

Well, I figured I owed it to myself.

Let's just say I needed cheering up.

A little more now on this little war I'm waging with the greatest gloss paint the world has ever known – Narrative. I suppose I should explain that my next poem was inspired by my house, as seen on my return. Again, the

lists are there to record the actual detritus that was my jet-lagged mind, and I ask you to draw no inference from them and to make no connections between items, which I have placed on the page in such a way as to highlight their affinity to inert gases.

(SHOW PAGE)

I drew from two to-do lists, another list of points I'd lost by being away for five days, and various comments made to me by friends and acquaintances, so many of whom remarked on the shift in my accent. The Story God would sand all this over to say that I had a relatively smooth transition back into home life. I think this poem suggests otherwise.

The title, I hope, is self-explanatory.

The reference to various strange goings-on in the Sonoran desert will, I hope, destablise any concept of Englishness that might emerge from the last stanza. I was home, you see. But not *at* home.

Not at all.

(THIS TIME REALLY GLARE AT THE AUDIENCE, AND I MEAN REALLY, BE AS SCARY AS SELIMA HILL)

While the Story God Sleeps

I suppose this is a good a time as any to admit that I have slugs in my house. I think I'll stop there and just read you the poem, which is very short, and rather brutal, and still rather shocking, as I don't see myself in it at all.

It's called *Slug*.

Unusually for me, it's in rhyming couplets.

Slug

The next thing I'm going to read to you is a sequence called 'Reading Upside Down.' Does anyone else in this room have this silly habit.

No?

(SMALL LAUGH)

What I did was take a few titles I was reading upside and run with them.

Well, you know what I mean.

It was quite a mixed bag, so let me give you a taster:

Bowling Alone

Better Together

Academic Diary 2003–2004–04–28

Under the Olive Tree – Family and Food in Lugano and the Cost

Smerelda, Italy

Key Stage Two SCIENCE: *The Important Bits*

Judge Backs Angry Fathers Over Contact with Children

China Hands

The Government and Politics of the European Union

The Making of Europe's Constitution

The idea here was to hijack the narrative… give it wing. For each is born of free association. The idea was to make it so real even I believed it.

I hope you don't mind if I put my glasses on my forehead. Like this:

(PUT GLASSES ON FOREHEAD AGAIN)

(SURVEY THE ROOM FROM SIDE TO SIDE, AS IF YOU'RE ABOUT TO SPILL A REALLY GOOD SECRET)

Reading Upside Down

And now for a sequence about two writers in love… which I know is a cop-out, but if you can't read a poem like this to an audience like this, then you may as well not write them, which may be just what you were just thinking.

Moving on now…

I originally called this *War by Metaphor* and I think you'll sense the joy I felt after my period of self-imposed abstinence.

The titles are direct quotes from a real person, let's call him X. Some of these are in response to the work I've been reading to you. Others are questions about money, bills, where the coffee mugs should go and so on. The final one is a remark X once made when I won a prize: Pass the Sugar.

And that, in fact, is the title of the whole sequence.

I think I'll use two voices. A deep voice for the title-quotations, and I hope you'll recognise this voice for being a pale but cruel imitation of You-Know-

Whose. So that's the voice I'll use for the titles, okay? And I'll use my own voice for the metaphors that follow each title. My intention here was to find the image that best expressed my feelings about the vicious thing he'd just said.

It's all rather dark and ugly so I'm glad to see there are no children in the room.

How much time do I have, by the way?

Pass the Sugar

It occurs to me that the sequence of poems I've read so far paint a rather worrying self-portrait! A soul stripped bare and found to consist of to-do lists and death wish metaphors… a soul washed up on shifting sands… and a disintegrating marriage to boot!

I suppose one of the things that first attracted me to poetry – aside from the music, the essence, the wild theatricality of words – is that it allowed me to express my innermost feelings without anyone – even my husband! – knowing.

My *then* husband, I should say.

That said, this next poem is, to use a tired phrase, cutting pretty close to the bone.

This indeed was its original title: *Close to the Bone*. Later shortened to *Bone*. But as I was resisting irony as well as narrative and metaphor at the time, I decided to live dangerously and call a spade a spade, and a balding man a balding man, and a limp organ a jack of no trade.

So with no more ado…

Ah yes! The title. It's *Old Lovers*.

You may recognise one or two of them.

Old Lovers
You May Recognise One or Two of Them

The next poem is an exploding triple sestina inspired by something I didn't say to one of them.

Fuck Off, You Old Dog

I don't know about you, but I harbour a deep resentment of novelists. Oh, I don't know, for all sorts of reasons. The money they make, the dullness of their sentences, those droning passes in which there is ONE TEENY TINY VERY SPECIAL HONED-DOWN SCULPTURAL MIRACLE OF AN IMAGE, and then it's a veritable Sonoran desert of nothingness for the next twenty pages and somehow this is meant to be redeemed by all these WONDERFUL INVISIBLE TRANSFORMATIONS going on BEYOND THE PAGE in the FICTIVE WORLD inhabited by those IMPLAUSIBLE STICK FIGURES they call CHARACTERS. Huh!

Well, perhaps we should just say "they don't know any better" and leave it at that. And so I will. I think, bearing in mind the company, I shall skip over this next one. Suffice it to say that I bear the most venom for poets who write novels for motives that can ONLY be described as mercantile.

The title of this poem I'm not going to read you is:

Old Dog, How I Hate You

How much time do I have?

Ah.

Well, in that case, let me move on to my penultimate poem, which is entitled...

(PAUSE)

(SIGH)

(PURSE LIPS)

(SMILE CAPRICIOUSLY)

Penultimate Poem

I don't know about you, but there is an ineffable moment in all poetry readings when you peer through the dark at your watch and think, dear Lord, how much longer? And then, if you hear the poet at the podium utter the words "and now, for my penultimate poem" you sigh.

So here's your chance! Sigh!

So that was the good news. Now here's the bad news. Here's what the title really is. It's three words, not two. In other words:

Pen Ultimate Poems

Get it?

Note that all-important 'S'.

Don't worry. They're all very short.

And they're all named after wives. Not in any order, but you can count on one thing! All the wives come second. So we start with Einstein's wife, move on to Disraeli's wife and Hockney's wife and…

He didn't? Are you sure?

Never mind. It's the thought that counts.

Moving onwards and upwards…

I don't know about you, but I prefer black ink to blue. Except when I'm in Guadeloupe. Why is that, I wonder? Is it the colour of the sea? No, it must be the rocks. It must be…

The thing I love about poetry is that you can change the subject whenever you like and almost miss the point while, also, putting, commas, wherever, the hell, you, want.

If only there were more money in it. If only the perks were larger… do you know, I almost made a Freudian slip there. Which segues nicely into my next poem – the last but one! I promise! This one was inspired by a rather steamy weekend in Prague last – when was it, Poo Bear? False alarm! I remember now! October 17th. As if it matters, but there you are.

Anyway. There we were in the hotel room, and I made a rather large one. Never mind about what. What a long face, Poo Bear! You thought it was funny enough at the time. Goodness me! Male egos. Gracious! You'd think I'd written an ode. But this is not about you, darling. It's about Freud. In a slip.

You may recognise the hair, however. And the glasses. And the nickname. All other details are the products of my perversely polymorphous imagination.

(NOT EVEN THE HINT OF A SMILE HERE)
(THIS IS A SERIOUS BUSINESS)

Freud, In a Slip

And now for my last but one. I mean really. I'm not joking. Would I be presuming too much if I asked you to close your eyes? Thank you. If you're not asleep yet, nod. Good. Thanks, all three of you. Now I'd like you to clear your heads of all thoughts. Breathe deeply. Now open your eyes and look at me. No, not at *him*. At *me*.

One of the other things I so love about poetry is that it leaves me so much free time. I like to try and spend some of that time meditating. The poem I'm about to read you is the fruit of a long morning I devoted to just that. And if any of you out there in the semi-darkness meditate too, I don't need to explain that on the morning in question, I was resisting not just metaphor and irony but reality: the telephone, mirrors, chocolate biscuits. I really tried to burrow into that back cupboard of my brain where my imagination hibernates when the needs of a Great Man take precedence over my own.

And God only knows. They're all Great, aren't they? Well, on the morning in question, I managed, by exerting almost every molecule in my body, to resist that receding tide, hold something back just long enough to savour it. And then....

Moose Jaw!

Pardon? Could you repeat that? Oh, am I? That much? Goodness. Are you sure? Are those medium-sized mama bear minutes, may I ask, or great big papa bear minutes?

Oh, I see.

Yes, of course.

Actually, I have a train to catch myself.

You could have said that more graciously.

Yes, I really do think so.

Yes, I really do insist.

Now, if you've been clocking our friend here… but you wouldn't do that to *him*, would you? Oh, no, you wouldn't risk alienating Mr Big. Big to his admirers, anyway. For those of us who…

Well, you know what you-know-who said about doing you-know-what with him. *Well*. Just you listen to this. She said it was like trying to push an oyster into a marking meter.

As it happens, you're right. She did indeed once say the very same thing about Norman Mailer. What can I say? She's had a very sad life.

If I had more time, I'd tell you about it.

But enough about that.

Time for my grand finale.

My last poem is actually a puzzle so complex that you'd need eleven notebooks and a fortnight in a waterless shed on the far side of Ios just to get warm. But here's a clue. It's about a murder, a murder that is all the more reprehensible for being metaphorical. It's about a woman stripped of love, lovers, money, happiness, identity and the soothing balm of irony.

A woman left with her words.

Her words are her lovers.

One of the things I like about this poem is it sums about almost everything I've ever cared about in my entire life.

One of the things I most cherish about poetry is that it can say so much, in such a compressed space.

But I hope you don't mind if I pause here to explain a reference in the third line of the 39th stanza.

It's not a play on words.

The bastard really did rape me with a toothbrush.

It wasn't a sex game. Just in case he ever told you that.

Or if it was, it certainly wasn't a consensual one.

So now you understand why I never took him to court. They would have laughed. Just like you!

But as I say in the poem itself, I don't care, you can go fuck yourself.

Poetry is the best revenge. You can tell the truth and get away with it, just by jigging things around and leaving out the most important words, so that no one knows what the hell you're talking about

Until you find
 yourself
held hostage
 by your own excellent manners
listening to a
 poet you did not come
 to see.

There really is a gun in my pocket.

That's a joke!

It's also the second line of the poem.

I think I'll stop there, and let it speak for itself.

All I'll say, then, is that I wrote it with every molecule in my body.

And every detail I mention in it is drawn from life.

I really did see an electronic clavier the other day.

And that same afternoon, someone showed me a truly gruesome photograph of shark fins. Thousands of them! I'm told this is a nouveau riche delicacy in some parts of China.

Both these sensory assaults found their way into this poem, which is best understood, I think, as my way of declaring war on all of you, using the very weapons that you have used on me.

If you feel, by the end of the 81st stanza, that you have died 81 deaths, please rest assured that this is just the effect I was trying to achieve.

(DRINK DEEPLY FROM YOUR GLASS OF WATER)

(TAKE ONE LAST LOOK AT EVERYONE)

(INCLUDING HIM)

(REMEMBER: YOU'RE NOT GOING TO HAVE ANOTHER CHANCE
 LIKE THIS FOR A VERY LONG TIME)

(SO SAVOUR THE MOMENT)

(THEN SIGH)

(GAZE DOWN AT THE PAGE)

(BEHOLD THE CRUEL MIRACLE OF POETRY)

(THE TITLE IN PARTICULAR)

(YOUR LIFE SUMMED UP IN TWO WORDS)

(HOW BRILLIANT YOU ARE! HOW BRAVE! HOW BEREFT!)

(NOW LOOK UP)

(SMILE)

(WITH EVERY MOLECULE IN YOUR BODY, PREPARE TO UNLEASH
THE MUSE)

(BUT FOR ONCE REFUSE TO GIVE OF YOURSELF)

(LET THE SILENCE PIN THEM TO THEIR CHAIRS)

(WAIT FOR THE COUGHS AND THEN COUNT THEM)

(LOOK AT THEM! SUCH SHEEP!)

(NOW LOOK AT HIM)

(GOD! WHATEVER DID YOU SEE IN HIM?)

(LET YOUR EYES TRAVEL AWAY FROM HIM SO THAT HE KNOWS
THIS IS THE THOUGHT THAT IS CROSSING YOUR MIND)

(NOW GATHER YOUR BOOKS)

(HOLD YOUR HEAD UP HIGH)

(LEAVE THE STAGE)

(REMEMBERING TO TAKE YOUR HANDBAG WITH YOU)

(JUST BEFORE YOU REACH THE EXIT, PAUSE)

(DRINK IN THE SILENCE)

(AND THEN, WITH EVERY MOLECULE IN YOUR BODY)

(SEIZE THE MOMENT)

(HOWEVER THE MOMENT SEIZES YOU)

(ISN'T THIS WHY YOU BECAME A POET?)

(TO HAVE THE LAST WORD?)

(YOU WOULDN'T WANT ANYONE ELSE TO HAVE THAT PLEASURE,
WOULD YOU?)

(SO GO FOR IT GIRL!)

(SO PICK UP THAT HANDBAG)

(IMAGINE YOU'RE HURLING IT AGAINST THE BACK OF HIS
HEAD)

(WATCH THE AUDIENCE RELAX NOW THEY THINK THEY'RE
SHOT OF YOU)
(AND IN YOUR LOUDEST, MOST IMPERIOUS VOICE, HIT THEM
WITH YOUR EPITAPH)

Poor Me

Mrs Cross's Epithalamium

TONY HALLIDAY

In accordance with her highest aspirations, Mrs Cross (George Eliot) is returning to you today from the other side. She initially intended to hymn the pleasures which marriage to a toyboy brings the middle-aged writer, but decided on reflection that biographical speculation should not be encouraged:

It were all the same
Were I the Virgin Mother and my stage
The opening heavens at the Judgement Day:
Gossips would peep, jog elbows, rate the price
Of such a woman in the social mart.
What were the drama of the world to them,
Unless they felt the hell-prong?

She rejects Christianity and its cult of personal immortality, 'in scorn for miserable aims that end with self'. Instead, she embraces the immortality achieved by Jubal, inventor of music – survival not as the singer, but the song:

This wonder which my soul hath found,
This heart of music in the might of sound.

Wouldst thou have asked aught else from any god –
Whether with gleaming feet on earth he trod
Or thundered through the skies – aught else for share
Of mortal good, than in thy soul to bear
The growth of song, and feel the sweet unrest
Of the world's spring-tide in thy conscious breast?

No, thou hadst grasped thy lot with all its pain,
Nor loosed it any painless lot to gain
Where music's voice was silent; for thy fate
Was human music's self incorporate:
Thy senses' keenness and thy passionate strife
Were flesh of her flesh and her womb of life.

This was thy lot, to feel, create, bestow,
And that immeasurable life to know
From which the fleshly self falls shrivelled, dead,
A seed primeval that has forests bred.

Thy limbs shall lie, dark, tombless on this sod,
Because thou shinest in man's soul, a god,
Who found and gave new passion and new joy
That nought but earth's destruction can destroy.
Thy gifts to give was thine of men alone:
'Twas but in giving that thou couldst atone
For too much wealth amid their poverty.

If her words are not easily decipherable, this is likely to be because of physical factors – the distance in time and space which her voice has to cover, the questionable character of the vessel through whom it will manifest – not to any sybilline pretension on the part of the author herself. Unable to speak with her own voice, Mrs Cross will make herself heard by means of a swazzle, an instrument almost as ancient as Jubal's lyre, but one which permits only a limited articulation of consonants.

So to live is heaven:
To make undying music in the world,
Breathing as beauteous order that controls
With growing sway the growing life of man.

Preservations

MARY MADDEN

I didn't fancy it, but Kate is a *Fortean Times* girl and can be very persuasive in her pursuit of the peculiar. She soon had me examining horse-riding, chess-playing corpses at some crazy German's freak show. Kate was positively evangelical, she kept banging on about how this was beyond art; it was enlightenment. It was a challenge to the patronising State that conspired to keep the wonders of anatomy secret from ordinary people. I told her the exhibition gave me the full on creeps. She said I was scared of science and truth. I was a hypocrite, happy enough to watch corpses and operations on TV but I couldn't handle the real thing. Miffed, I told her that the assemblage of plastic leftovers playing chess with its brains out in front of us didn't strike me as all that convincing a depiction of reality. Our bickering was reasonably amicable until she announced she was going to donate her body to the cause.

"Don't I get a say in it?"

"Why should you?"

Charming. In the five years we'd spent together she'd consulted me about 26 billion micro-aspects of her body; "Shall I get my belly pierced?" "Do you think I should get that mole looked at?"; "How fat is my arse in these trousers?" But apparently she didn't give a damn what I thought should happen to her body when she was dead.

"Why do you want to do it?"

"It's useful."

"So is bricklaying but you don't want to do that."

I told her I reckoned it was an ego trip and she went ballistic. "That's just not true! Von Hagens takes great pains to anonymise his specimens. Even their own families don't recognise most of them. Where's the ego in that?

An ego trip is wanting to have your head frozen like Walt Disney or making a monument out of yourself like Jeremy Bentham."

Now, even non-*Fortean Times* readers know that Walt Disney's head is on ice somewhere ready to be thawed out, grafted on to a new body and brought back to life. But Jeremy Bentham? I hadn't heard anything about him since school.

"What's Bentham got to do with it?"

"You've not heard of the Auto-Icon?"

"What's an Auto-Icon when it's at home doing the dishes?"

"Go and have a look. He's at University College on Gower Street." Kate stomped off to find one of Von Hagen's henchmen. I did as I was told and went to Gower Street.

<center>⋆</center>

"Somebody here to see Mr Bentham."

"Tell them he's just popped out for a minute."

The porters on the gate at the University entertained themselves with their regular routine before giving me directions to a gloomy corridor. There, against a wall were Jeremy Bentham's dissected and reassembled remains sitting in a display cabinet. I pressed my nose against the glass. It wasn't there for long when I was stirred by a voice behind me:

"Camp isn't he?" I turned round to see a friendly-faced woman clutching a bunch of files. "That's his favourite walking stick, 'Dapple'."

"Oh, hi. Yes, as the proverbial row of pink tents."

"The board of governors still wheel him into meetings you know. They record him as, 'present but not voting'. He's probably got a seat in the House of Lords too."

I laughed. She was cute.

"Do you work here?"

"Yep, but don't blink, I'm the latest in a long line of temporary lecturers. You?"

"No. Just visiting. A friend told me about him so I came for a look." We stared at the cabinet and its contents for a minute. "That's not his real head is it?"

"No. They couldn't preserve it properly, so they made one out of wax; wouldn't do for a great man to live on looking like a shrivelled up prune, would it?" I shrugged and offered, "nice hat". She nodded agreement.

"What exactly is he doing here?"

"Why fork out for an expensive statue when you can have the real thing? The pigeons can't crap on him and the worms don't bother him. It is a shame about his head though. It was supposed to be kept for phrenological demonstration. There are marvellous things to be learned from the lumps on great men's heads apparently. It's all in his will. He left his body to a Dr Southwood Smith for public dissection. Afterwards, he was to prepare the body for a display cabinet, not a grave. I think Bentham saw himself as some sort of example. Dissection is not to be feared, that kind of thing. A big dose of vanity in it too of course. Nice meeting you. Got to go, I'm teaching now."

"Oh, right, thanks."

Ms Cute was gone. Alone again, I found it hard to believe that this was a genuine corpse. I walked around the cabinet so I could view him from all sides. I was pushing my nose against the glass for a second time when I heard another voice."

"Straw."

"Eh?" I turned around. If Bentham was Worzel Gummidge's better-dressed brother, the creature behind me was Baldrick on a bad hair day.

"He's stuffed with straw. Bastard."

"I take it you're not a fan?"

"See down there, 'a voluntary sacrifice for the sake of a good'? Rubbish. Scared of the body snatchers more like. He let his friend have a go with the knife, but only on condition that he stitched him up again and stuck him on his throne for all to admire." I bent down to have a closer look at the plaque.

"But surely there was some good in getting people to donate their bodies to medical science?" No answer. My scruffy companion had moved on. I walked around the cabinet one more time before deciding that I'd had my fill of Auto-Icons. I waved a cheery goodbye but couldn't move myself away. It was then that a thick voice poured itself down my spine.

MARK FAIRNINGTON *Musk Deer*

★

"I thought you'd believe me. You believe all the rubbish that's in those magazines."

"I didn't say I didn't believe you. I just said you'd had a very heightened day, maybe you heard echoes in the corridor."

"It wasn't echoes, it was… Oh I don't know. I didn't just hear it, I felt it, and it wasn't just in my head. It said something about worms destroying a body but in flesh it would see God; or something like that. It scared the living crap out of me."

"You know, it's ringing some big bells. Resurrection? I've got an old Catechism here somewhere." Kate hopped out of bed and rummaged in her heaving bookshelves. "Here it is. Look, the eleventh article of the Creed is the resurrection of the body. It says 'the bodies of the just will be immortal and have the four gifts of impassibility, which will prevent them suffering; agility, which will enable them to pass as swift as thought from one end of creation to the other; brightness, which will make them shine like stars for all eternity and subtlety, which will enable them to overcome all obstacles.' Bloody hell, it's no wonder I'm the way I am. Father Murtagh used to shout this kind of stuff at us at school."

"We had Father Twomey, he was quite sweet. Well, at least Bentham's got all his bits for Judgement Day. Except his head; that's gone off. Look, I'm knackered and a hundred per cent freaked out. I want to go to sleep and forget about it. That Arty git friend of yours is coming round tomorrow isn't he? He knows everything about everything. Let's ask him about the Auto-Icon, but not a word about what happened, right?"

<center>*</center>

"I fancy seeing the one with the boot and no arse."

"Actually, it's a shoe, not a boot. A brogue."

"Is it Protestant or Catholic?"

"Er Protestant I think, if… "

"In that case do you think it will be bothered by having no arse on Judgement Day?"

Arty git had been boring on for hours about a new show he'd been to see. Kate had gone out for more drink, so I was taking the opportunity to introduce matters of life and death.

"I mean, Judgement Day's about the resurrection of the body, not just the soul. What is St. Peter going to say to a boot with no arse at the Pearly Gates?"

"I can't say I've thought the theology of it through very much."

"Talking about arses and the afterlife, do you know anything about Bentham's Auto-Icon? Kate mentioned it yesterday when we were at Von Hagen's *Body Worlds* exhibition." I knew he wouldn't be able to resist an invitation to educate me.

"Well, actually yes, I do know a bit about it. One of my friends made a piece called, 'necro-tour' a few years back. It was about links between artists and anatomists in London. Did you know that in the Art School basement at the Royal Academy, there are two plaster casts of men executed at Tyburn?… "

As always, I had trouble concentrating on what Arty git was saying. It wasn't that he wasn't interesting or I didn't understand when he lapsed into post-structuralistese. I just found him really irritating and that distracted me. I tried to listen, but I ended up staring at his preachy mouth and his wavy hands.

"…Their flayed cadavers were posed while warm and left until rigor mortis set in. Their moulded bodies were then cast in plaster and used as artist's models. One was crucified and another is in the posture of the 'Dying Gladiator'… "

"And Bentham?" I interrupted. I didn't want the full tour.

"I went with Annabelle to see the Auto-Icon when she was doing her research. I suppose it's an example of too much rationalism breeding madness. Annabelle called it a secular resurrection, a fantasy of bodily immortality…"

Arty git has got loads of little holes in his nose. Kate thinks he fancies her.

" …Bentham was very English. He had no time for fiction when you could have fact. He said, 'all poetry is misrepresentation.' He didn't see what service fanciful words might be to humanity. I suppose he thought that preserving his real body cut out the problem of imperfect representation."

"Do you think he was scared of grave-robbers?" I was trying to tune in.

"I'm not sure. But I know he put them out of business… "

Could she ever fancy him? Imagine those holes in mega close-up.

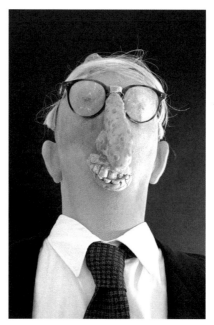

JOÃO PENALVA Poster for *Mister*

"In the time of the 'Dying Gladiator', the only bodies legally available to artists and anatomists were those of murderers. They were pretty quick to execute back then, but only criminals executed for murder were dissected afterwards. I suppose it was a fate worse than death… "

He'd better keep his wavy paws to himself.

"Body snatchers filled the gap in the market and gave anatomy a bad name. Bentham provided a solution. He was eager to make the poor more productive and had plans for labour camps that would turn pauper 'dross' into profitable 'sterling'. The camps were never built, but his Anatomy Act meant that unclaimed corpses from workhouses were available for dissection. Some think that's why there was so much fear of the workhouse. Not just because it was grim, but because going there could literally be, 'soul destroying'… "

I didn't want anyone messing with my Kate.

★

Arty git was maundering on about metaphysics by the time Kate came back with the booze. I poured fresh drinks and filled her in on what I'd gathered so far.

"Bentham wrote this Act that meant some poor sod left in an institution with no family to claim him could expect the treatment that used to be reserved for murderers – dissection. Typical. The poor have to rise above their superstitions so the rich can develop viagra and spend less cash on reinforcing their tombs."

"That's a bit reductive isn't it?" interjected Arty. "A bit of a travesty of the history of Western medicine, and to be fair, Bentham was dissected as well."

"Hmm." I considered his point and added, "Bastard."

There was a discomfiting silence. Kate tried to oil the social waters with talk of a television programme she had watched during the week.

"It was that French artist Orlan. Do you remember? She did live broadcasts of plastic surgery on her own body?"

"Yes, I remember, it was revolting. She made pictures with the trimmings."

"Well, not quite, but don't you think it was interesting about the way we cling to the body as some sort of truth of identity? Our bodies are unavoidably changing so we want to stop them and never get old. On the other hand it's like they're not plastic enough, so we resort to drastic measures to improve them."

"Uh, oh, you're going on one of your rants against plastic surgery aren't you? You love anything with plastic surgery in it. Then you sit and moan your way through it all."

"Shut up Madelaine or I'll tell him about the voice."

"What voice?" Arty git was curious, but we bickered on regardless.

"Kate's been hearing voices telling her to get plastinated."

"Get stuffed Mal. Worry less about my funny ideas and more about your own."

Despite myself I was feeling some pressure to explain:

"It's just that I thought I heard something when I went to see the Auto-Icon."

"Heard what? A ghost?" enquired Arty smugly.

"That's a bit reductive isn't it?" I snapped. There was no way I was going to talk about my inner fears with this git. "It was probably just Bentham talking through his boot."

> *George Eliot (Mary Ann Evans) included a Benthamite woman in* Scenes from Clerical Life *(1858):*
>
> *Her intellect told her that to pay [her servants] more than the market rate, to exact fewer than the customary hours or insist on less than the usual strain, even if it could be proved that these conditions were injurious to the health and happiness of the persons concerned, was an act of indulgence, a defiance of nature's laws, which would bring disaster to the individual and the community. Similarly, it was the bounden duty of every individual to better his social status, to ignore those beneath him, and to aim steadily at the top rung of the ladder.*

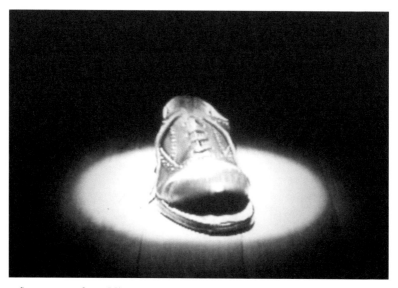

JOÃO PENALVA from *Mister*

From Doctor Watson's Casebook
Infallible: In Search of the Real George Eliot

DUNCAN MCLAREN

It's late when Sherlock hears the familiar sounds of a man walking up the single flight of twenty stairs that leads to his study.

"Ah, Watson, excellent timing! I have just enjoyed an evening of musing about our latest case and am in the mood for light distraction. So don't delay. Tell me: how was the private view?"

"Hello, Holmes," says Watson wearily, sitting down in his customary arm-chair opposite the detective. "It's wet outside," says the doctor, who would have liked to have left it at that and retired to bed. But an assessing glance at Sherlock pacing energetically about the room – bristling with unspent mental energy – informs Watson that he would never get away with such a course of action. But he would – he really would – have liked to have been left in peace for a couple of minutes, for once in his life. Yes, a couple of minutes just sitting here in front of the fire. That would be lovely…

"You say it's wet, but you're tinder dry Watson! And even allowing for the fact that you've taken off your coat and hung it up on the rack downstairs, the bottom of your trousers are not wet, nor are your brogues. You've been sitting in a cab all the way from the East End! Which means you're well enough rested. So come on man, spit it out! What did you see tonight?" And Sherlock sits down opposite his confounded friend, still talking twelve to the dozen. "I remember being intrigued by the promotional piece of literature that came through the letter box. It claimed, if I remember rightly, that the exhibition would present work that explored fiction, ventriloquism and disguise: 'From the mimetic fictions of realist painting to the comic excesses of fancy dress.' So, no more sulking in an unbecoming silence, Watson. Give me the benefit of your eyes and ears."

"What, Holmes?" replies Watson, desperately trying to get his mind into gear.

"Tell me what you *saw* and *heard*, Watson. You can leave the rest to me."

Watson changes position in his seat, and to his considerable relief a recollection flies to mind. "Well, for a start there was an amazing drawing machine."

Sherlock almost bounces up and down in his seat, such is his enthusiasm for even this paucity of information. "Full title*: Power, Politics and Portraiture – Ralph Wolf and his Amazing Drawing Machine.* Yes, it said as much on the publicity. And this Mr Wolf and the machine for which he makes such grandiose claims, were they physically present in the gallery?"

"Er… no, I don't think so. Just some sketches on the wall. But these were amazing enough. It seems this Mr Wolf was invited to a drawing class, and for some reason he started drawing with an outlandishly long-handled implement."

"Drawing or painting?"

"Er… painting I suppose. Yes, now I think of it, he could change the ends of the stick by attaching different brushes. But really the main thing has to be that he was sitting in this wheelchair contraption, with an easel attached to the chair but 12 feet in front of where he sat with this eighteen-foot long brush under his arm…"

"Like something out of Don Quixote. The mad knight tilting at windmills."

"What's that, Holmes?"

"Never mind. Carry on, Watson. What did Mr Wolf actually paint with his amazing machine?"

"Well, somebody at the gallery was telling me about this. At first it was his own name. Over and over again. And it was so frustrating for him that the signature was indecipherable. He decided this was not the direction forward for his drawing machine. Instead he wheeled himself about the studio and painted his fellow artists. For instance he painted a picture of a colleague conventionally painting a bear."

"Ah, do you realise exactly what it is we have here, Watson? – power, politics and portraiture. You see with his amazing machine, Wolf would have

completely dominated the drawing class. Ostensibly painting his fellows, he was in fact exercising the most basic power over them. 'Come everyone! Look at me and my amazing drawing machine!'"

"I believe you're right Holmes."

"And yet, Watson. The fact that the work is represented by a simple sketch, means that in the end, the power is invested in the humble draughtsman with his perfectly ordinary-sized pencil. The equivalent of Don Cervantes shall we say."

Watson decides to ignore the reference, though he can't stop the name of Sancho Panza briefly flitting through his mind. "Mmm. And do you think Mr Ralph Wolf is aware of the way in which the power struggle ends."

"A curious question, Watson. Does Cervantes not know better than any other the imbecility of Don Quixote, his own creation?"

Watson is silent. He's thinking that only last week Holmes had described himself as the world's most famous consulting detective. He's thinking also that it is he, Doctor John H Watson who writes up the cases after Holmes has solved them, and presents the work to an admiring public. Perhaps he will call the next successfully completed case *Sherlock Holmes and his Amazing Detective Machine*. But better think that through before committing himself to any such bold course of action. And no time to do that now, because the impatient and curious Holmes needs to be thrown another bone.

"What else then, Watson? Come on, man, don't keep me waiting!"

"Well, I should really leave this until last since it was just about the most singular performance I've ever seen."

"Performance?"

"Yes, you see as well as the more traditional stuff on walls, there were things happening that you could watch in the gallery. Like little plays. So, for instance, in a dark room were some rows of seats into which we all sat in front of a stage at the appointed time. And on that stage was a talking boot under a spotlight."

"Details, please."

"Just an old brogue where the upper had come away from the sole. So you had a mouth-shaped gap at the toe end."

"Seen front-on, or in profile?"

"Front on, Holmes."

"I see the boot smiling. Pray continue."

"Well, the upper moved in time with this voice which seemed to emanate from the boot itself."

"I suppose the artist was under the stage, and – as a recorded voice told its tale – the fingers of one of the artist's hands moved the loose upper up and down, while his thumb somehow kept the sole pressed hard to the floorboard."

"Er… yes. I dare say that's what was happening, Holmes. The artist's name is João Penalva, by the way, and the voice was that of an Ulsterman. So, yes, I suppose there were two people involved."

"The one wrote the words for the other, so that the other would speak the words aloud while the first created an image to go with the spoken words. It *could* all have been done by the one person. But there's no reason why it should have been, particularly if it was a certain distinctive other voice the artist himself was after." Sherlock pauses, as if checking his own logic. Then, apparently satisfied, adds: "Continue, Watson."

"Well, this voice was just wonderful. And as it told its story I sat there entranced. This Irishman lost an arm in the war. Then later he lost a leg when gangrene set in to an old war wound as a result of diabetes. (I see this all the time in my own surgery, Holmes.) Next to go was the Irishman's lung, (probably as a result of smoking, though of course the medical establishment is still a long way from accepting that disease of the lung and smoking tobacco are in any way related). Anyway, the audience was getting all this dreadful information in a strong, straight-talking Irish voice. Full of earthy humour, Holmes. Let's see if I can give you an example."

"By all means."

"I can hear the voice so clearly still, I should be able to give you an extract more or less verbatim," Watson slightly raises his mouth at the right side,

and when he next speaks it is in an Irish accent. "*'But that wasn't the end of it. Sure there was al-l-l-ways sumthin' else. And it's name was cancer. Cancer of the rectum. That's the arse to youse – pardon my language…'*"

Sherlock has to admit that Watson does do a fair imitation of a Protestant Irish accent, profanities and all.

"*… 'So the bluddy doctors they sewed up me arse, and gave me a box, and from then on that was what I hud to shit into. You don't even know that's what it is yer doin, cos it's happenin' all the time, like. And it was only then I realised how much you can miss havin' a good crap. So instead of carryin' around my shit inside me as I'd always done, without givin' it a thought, I was carryin' it around in a box outside me, as I do to this day.*' So, Holmes, it sounded something like that. Next to go was his pecker, as he called it. Then he was given a pig's bladder to replace his own. And then he began to grow great lumps on his head – I'll spare you the medical terms for these horrors, Holmes, just as he was spared the medical term. 'Potatohead', he was called as he shuffled around the village, and he was not at all happy about that."

"No, I don't see how he could have been happy in the circumstances."

"But, the weird thing is – the way it was put over – it was funny, Holmes, I laughed aloud more than once. But then when – despite the brave face he was putting on it – I realised that this man had been pushed to the very end of his tether, time and time again, and had survived. Well, I was moved."

The detective looks away from his friend as Watson fights to retain his composure.

"Sorry, Holmes. Got a bit of a cold. Where was I?"

"One-armed, one-legged, one-lunged, arseless, peckerless, pig-bladdered and potato-headed. I think that just about covers it, Watson."

"Quite, Holmes. Towards the end of the performance, the old boot started to go on about God and his infinite wisdom. Invoking the Book of Job belittlingly, and generally turning against the religion he'd accepted without questioning throughout his early years. Except, a kind of crazy and perverted belief did remain. The Ulsterman would have gassed himself in the oven by this stage, except he reckoned that, at the Pearly Gates, God would have

said to him that it had been written that his days would end with him taking his own life in just such a way."

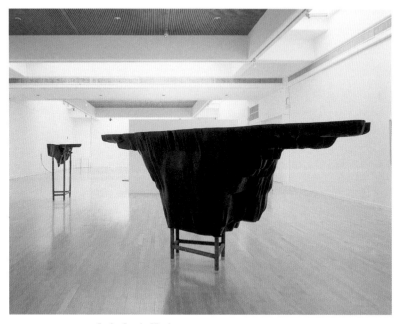

BRIGITTE JURACK *Lake Issyk-Kool*

Sherlock nods: "I suppose he bitterly resented the idea that no free will exists, and that everything is pre-ordained. He resented it because he, poor soul that he undoubtedly was, wanted the credit for taking up his long battle against pain and disability. But tell me, Watson, how did the Ulsterman's story end?"

"Rather confusingly, with the boot singing 'Pack up your troubles in you're old kit-bag'."

"Pack up your troubles in your old kit-bag, and smile, smile, smile…"

"Mmm, I suppose so."

"Pack up your troubles in your old kit bag, and smile boys that's the style."

"Please don't, Holmes. I'm seeing that grimacing mouth a little too clearly!"

"Tear your mind away from it then, Watson. By telling me what you saw or heard next."

"Well, after that extraordinary performance, I went into the main gallery and stood and stared into space for a while, trying to get the voice and the smile out of my mind. Then I realised I wasn't staring into the space after all, but at the strange work of Ian Kiaer: his *Endless House Project*. But look carefully, though I did at its component pieces, I simply have no idea what the artist was trying to convey."

"Well, let's start with a description. Eh, Watson?"

"I'll try, Holmes. But really there wasn't much to see. On the floor was a roughly cut, vaguely circular piece of rubber foam, the spotty top layer of which had been stripped off in places. And at one side of the circle was a tiny grey model of what I took to be ruined workers' cottages."

"And what else?"

"On the wall, at eye level, there was a painting of two geese swimming on a stretch of water. A grid had been drawn in pencil over the whole picture, and that distracted me from what might otherwise have been an idyllic scene. Though the colours were a bit washed out for my own taste. Having said that, my real trouble with the picture, Holmes, was that I couldn't link the geese with any aspect of the floor component."

Sherlock looks thoughtful: "You've told me the surface of the circle was two layers, one spotted. Now say, for the sake of argument, they represented water and ground. That would be consistent with the paragraph in the exhibition's publicity that talked about the honourable Sydney Waterlow, who in 1899 donated Waterlow Park to the general public. He was – and still is – chairman of the Improved Dwellings Company whose aim – I recall the curious phrase exactly – is 'to create a garden for the gardenless'."

"But these model houses were ruins, Holmes! Roofs for the roofless would surely be more to the point."

Sherlock is out of his seat and pacing the room: "Yes, Watson. But by giving us an image at head height – an idealistic mental construction shall we say – and contrasting that with the reality of the situation – a pond where no geese swim, a grey place with ruined houses, isn't he… "

"My God, I'm thinking of the Ulsterman now, Holmes. It must be the two geese swimming that have conjured him up. When telling the audience about losing his pecker, the Ulsterman also commented that it didn't matter that much, because his Edna had pre-deceased him." Sherlock wonders whether geese mated for life as it was said that swans did. Meanwhile, Watson continues: "But I'm also associating the geese with the boot, because the Ulsterman's last little story – immediately following his railing against God and immediately before his 'pack up your troubles' song – was also about a bird. He recalled that when he was a boy, a small bird had hopped onto his hand. The songster had allowed itself to be stroked. And the boy had thought how easy it would be to snuff out that bird's life just by pinching between finger and thumb the throat that was coming out with all the melodious warbling. Just a flutter of wing and that would be that. Eventually, the bird flew off, and the boy was pleased enough to see it go happily on its way. But then he looked down at his hand and… what were his exact words?"

"I don't know, Watson. You tell me."

"*'The little bugger had left me a present. He'd shat on me hand! Well, I laughed, so I did, and went off to tell all me friends about it.'* "

Sherlock ponders the information he's been given, trying to connect the little bird with the geese, the ruined workers cottages with Waterlow Park and the Amazing Drawing Machine. He knew that there wasn't a single pattern behind all the information and images that Watson was giving him, but he couldn't stop looking for a pattern anyway.

"Holmes?"

"One minute, Watson," says Sherlock, stalling. Watson's words, or rather the Ulsterman's were going round and round his head: '*The little bugger had left me a present…* An Amazing Drawing machine… *The little bugger had left*

me a present… A talking boot…*The little bugger had left me a present…*'
Waterlow Park in which a retired Ulsterman could pack up his troubles in
his old drawing machine until the final trouble came along and put him out
of his misery…

Watson now has what he thought he wanted when he came into the room
– to be left in peace to enjoy the warmth in the detective's study. But that is
no longer what the good doctor wants. Memories of earlier in the evening
are flooding back to him and he wants to share them with another human
being.

"Holmes?"

"Yes, Watson," says Sherlock, pulling himself out of an analysis he knew
to be premature. For there was little point in moving towards a solution of a
case before he'd heard all the facts.

"I want to tell you about this other performance now, but I don't know
where to begin."

"Is it not possible to begin at a beginning?"

"The performance had already started when I came across it. There were
people standing around watching and so I asked someone how long it had
been going on for. He looked at me and said, 'Oh, about three hours,' but I
think he must have been joking. Anyway, what we were looking at was
'L'école de Burrows and Bob Smith'. A funny sort of school that consisted
of two people dressed in robes arguing with each other in a locked room!
That was my initial reaction."

"A typical London art school, I suspect, Watson. But for the moment,
describe, Watson, only describe."

"Bob, a shaven headed man with a prominent nose, was being harangued
by Dave, the shorter and burlier of the pair, who was dressed in a maroon
robe that went from his shoulders to his boots. Actually, Dave was torturing
Bob in an effort to get him to denounce a book. The book was called some-
thing colloquial, and Bob refused to denounce it, even though he was being
stung by elastic bands that Dave was firing at him."

"Ah, so this was a comedy, Watson?"

"It was comedy all right, Holmes, and most of the audience laughed aloud from time to time. Dave put a large elastic band around Bob's bare head and pulled it some distance from the back of his skull. He threatened to let go of the elastic, which would smack into the back of Bob's head. And in the meantime, the elastic bit into the scalp of Bob's forehead in a no doubt painful way. "'Spit on the book!' said Dave. 'Aaah!' said Bob. 'Spit on the book!' said Dave. 'Aaah!' said Bob. 'Spit!' 'No, I won't. Matthew's a decent bloke,' said Bob. At that point Dave pulled tighter on the elastic band. "Oh, Jesus, Dave,' gasped Bob. 'Spit!' 'Aagh!' 'Spit!' 'Aagh!' 'Spit!' 'Aagh!' 'Spit!' 'Aagh!'..."

"All right, Watson, I get the picture."

"Sorry, Holmes, I got carried away. Anyway, eventually Bob just caved in. His resistance crumbled and he spat on the cover of his friend's book. And that was that."

"Really?"

"Well, no. Because in the next scene the tables were turned, and it was Bob that was haranguing Dave. He suspected Dave was hiding something down the front of his robe. Because – as he put it – he knew that Dave liked his food, but what he was looking at was suspiciously large. And sure enough, Bob bullied Dave into pulling out from within his robes a journal to which Dave had contributed. Bob was scathing about the obscure art periodical, which was called *Connect*, or *Control*, or something. Dave tried to defend the magazine and its editor, but Bob wasn't having any of it. He bound Dave, made him sit down on a chair, put a bucket over his head, and threatened to beat the bucket with a stick if Dave did not denounce the journal."

"And what happened next, Watson?" said Sherlock. "Oh, don't tell me: Dave refused to denounce the periodical. Bob beat the bucket with a stick causing Dave to shout out in pain."

"Exactly, Holmes! It was hilarious. Bob beat the bucket causing Dave great distress. 'Well, will you spit on the journal, then?' asked Bob. 'Yes,' said Dave, meekly. But when Bob took the bucket off Dave's head and

VOLKER EICHELMANN / ROLAND RUST *Martello Towers #15*

presented the cover of the periodical to be spat on, at the last minute Dave turned his head and spat on Bob instead."

"And the response from the audience?"

"Oh, we were amused, Holmes! Especially when Bob put the bucket back on Dave's head and really laid about it with the stick. *Whack*. '**Aaagh.**' *Whack* '**Aaagh.**' *Whack*. '**Aaagh!** Oh, please stop, Bob.' *Whack*. '**Aaagh!**'. Oh, no. Stop, stop.' 'Well, will you spit on the cover?' *Whack*. '**Aagh!**' *Whack*. '**Aaagh!**' *Whack*. '**Aagh!** Yes, yes. I'll spit on it.'... And so that was that."

"You mean Dave spat on *Connect* or *Control* or whatever the journal was called?" asks Sherlock, wanting to be clear about the conclusion to the scene, however puerile.

"He did indeed. And Bob wandered off smiling to himself and admiring his trophy."

Sherlock soon pronounces on what he's heard: "A curious game of self-humiliation, Watson. David Burrows' and Bob Smith's tastes are more or less the same, I would surmise. Each pretends to despise the other's almost identical views on aesthetics, and the position of the artist in society. And each pretends to reject those writings that attempt to prop up and legitimise the other's work."

Watson wonders what Holmes is talking about.

The detective continues: "But actually, rather than denounce the books that support the other's work, what the pair are really doing is producing a new piece of art that will be written about favourably both in Mr. Collings next book, and in the magazine *Connect and Control*. Moreover… "

But Watson isn't ready for this: "Hang on, Holmes, I haven't finished describing to you what happened. You see they went straight onto the next scene where Dave again had the upper hand. He gagged Bob and tortured him with all the horrors of a nine-volt battery. His purpose was to get him to spit on a Tate Gallery publication. Bob refused point blank to do this on the grounds that it was 'my only catalogue'. By which he meant… "

"I know what he meant, Watson," says Sherlock.

"Well, brave Bob simply would not spit on his glossy colour pages in the catalogue even under extreme duress. I have to say there were moments when it was clear that Bob was in genuine if superficial distress. And in the face of such stubbornness, Dave was forced to open a box of pegs."

"Pegs, Watson?"

"As in for holding clothes on a washing line."

"I see."

"Soon Bob was tied to a chair, his ears bristling with pegs. His conk too, and one on his lip. 'Spit on the book, Bob!' 'Never!' **'Spit on it!'** 'No.' 'Spit!' 'No!' 'Spit!' 'No.' 'Spit!' 'Never!' 'Spit!' 'No, no.' 'Spit!' 'Never!' 'Spit!'… "

"I take it there was no surprise ending."

"No surprise ending, Holmes."

"Bob spat on the book?"

"Yes," sighs Watson, "Bob spat on the book."

The detective looks thoughtful. "I must thank the school of Bob Smith and David Burrows for putting me on the trail of the real George Eliot, Watson." The detective follows up this enigmatic remark by walking over to a bookcase, and extracting a thick hardback from the top shelf. He opens the volume, turns a few pages, and stares at a passage somewhere near the middle of the volume.

When Holmes eventually turns over and goes on reading, Watson asks: "You're on the trail of the real George Eliot, Holmes?"

"Patience, Watson, patience," urges Sherlock, returning to his seat opposite that of his colleague, and continuing to leaf through the book. "And in the meantime, tell me more about this wonderful exhibition."

Watson wonders if he can bear to wait for what Holmes is going to come up with. In some ways he'd rather get it over with. On the other hand he was quite happy to do some more talking: "I think what happened next was another performance, from a Mr Tony Halliday, which took place at the same time as the book-denouncing. There was an appearance of a middle-aged man dressed in an elaborate lace wedding dress – though I was not in a position to see the apparition clearly."

Watson gets the impression that Holmes, his nose buried in *Middlemarch*, is not listening properly. But then Holmes not listening properly was still listening plenty. So Watson carries on: "It seemed as if this man had something to say to us all, but his words were rendered incomprehensible by being spoken into a swazzle, Holmes. I think the idea was that this was George Eliot returning in male spirit form, from the grave in which she was buried thirty-odd years ago. And that this accounted for the lack of clarity in her words."

Watson is now certain that Holmes is not listening. But he carries on as much for his own interest as for the detective's: "I was standing next to Lady Roxy Walsh, dressed in a sailor suit, who put together the whole show. And I have to say, Holmes that you can only pretend to be listening to swazzle noises for so long. So after a while I turned round to her and – cutting to the chase, as it were – took the opportunity of asking her about the real

George Eliot. Apparently, from her mid-thirties onwards, George Eliot – or Mary Ann Evans as she was christened – lived with an older man, and although they never married, he was the love of her life. However, this man predeceased 'George'. And very soon after, when she was sixty-years-old herself, she married a man twenty years her junior, whom she'd known for ten years and who looked after her financial affairs. Lady Roxy pointed out that such a marriage, with the woman being so much older than the man is a rare thing in any society."

Sherlock suddenly closes the book and places it on the arm of his seat. "If the lady has extreme wealth, it can happen. And George Eliot was the most successful writer of her day. She was rolling in it, Watson."

"Well, famous and wealthy she may have been. But as Lady Roxy told me that 'George' didn't get to enjoy her toy boy for long. She died within a few months of the wedding."

Sherlock was looking at the fat book beside him. "Curious that in this her great masterpiece, the situation is in an important way reversed."

"How do you mean?"

"The female protagonist first marries an older man out of a respect for his work – out of a misplaced sense of duty – and soon comes to pity him, and to realise she has made a terrible mistake. In the background is a younger man, a poor man of letters, a man of genuine talent rather than academic bent, and it is this idealistic and energetic youth she loves. The older man's death would seem to allow a chance of happiness. But a codicil in her husband's will means that she cannot inherit his wealth if she marries that particular younger man. The working through of the implications of this barrier to human happiness provides the core of the book."

"Holmes, I know you're going somewhere with this. But it's important for me to tell you what happened next at the private view. To tell you the truth I think I had blocked out of my mind some of what I am about to tell you. But I think it does need to be reported. May I?"

"I am all ears and all eyes, Watson, you know that."

"Out the back of the gallery a curious little tableau was to be played. Another little play, if you like, this one organised by ARTLAB."

"Lady Charlotte Cullinan and Lady Jeanine Richards, whose case I worked on last year?"

"The very same. Did we end up calling that episode 'The Strange Case of the Portable Library' Holmes?"

"All I do is solve the cases, Watson. You are the one who insists on writing everything down and giving it a name."

"Mmmm. I believe in the end I went for 'The Mystery of the Blue Whale,' or did I revert to… "

"And how were the honourable ladies?"

"In good spirits, Holmes. Lady Charlotte never stopped teasing me, as usual. And Lady Jeanine's new baby can completely look after itself now, at three months old, so she was jesting away also. Actually, they could have done with a more regular supply of wine, Holmes. But they only needed to hint at that for drinks to appear for them from several quarters at once."

"Capital, Watson. Was Paolo, with them?"

"He was, Holmes. And the charming Italian did say, more than once, that he had been a bit depressed lately. Of course, I did what I could to try and cheer him up, and so did Lady Charlotte and Lady Jeanine. But we had only made so much progress in that direction before the outdoor performance began, rain or no rain. The curtain opened and I could make out a table and bench in a clearing surrounded by trees. That was all, a bench/table construction that glowed in a clearing surrounded by trees. But a story unfolded, told by a voice which emanated from very close to me, Holmes… "

"Go on, Watson."

"Well, I should warn you that this story is pretty strong stuff. So if… "

"Get on with it, man!"

"Righty-oh. The narrator tells us that he was in the woods at night, looking for an assignation of an unspecified nature, and he came across this table and bench. Lying on the bench was a naked woman. And standing

around the piece of furniture were several men taking it in turns to… er… make love to this woman. One man was not taking part in the grim and grunt-filled orgy, but seemed to be a mere onlooker, as was our narrator… Are you following me, Holmes?"

"I'm hanging on your every word, Watson."

"The narrator walked about the wood, still looking for some assignation of his own, and he came across another table/bench on which the same man he'd talked to before lay naked. At least I think he was lying naked, Holmes. It's possible he was standing by the table. For sure he was on his own, and for sure that was not how he wanted to be. He wanted there to be men around the table… er… making love to him. Anyway, the narrator engaged the man in conversation again, established what I've just told you, and also that the woman being enjoyed by several other men earlier was in fact the neglected man's wife. It had been her turn then, and now it was his turn. The narrator pointed out that he wasn't getting as much attention as his wife had done. And the man, full of woe, had to admit that this was indeed the case… And that was about it."

"Hmmm."

"I should make clear, Holmes, that what struck me about the piece was firstly the unseen narrator's deadpan delivery. Really quite odd things were taken for granted, and accepted as everyday occurrences."

"And secondly?"

"And secondly the sense of sorrow that emanated from the forlorn figure of the cuckolded (is that the word?) husband, a sense of unhappiness that was subtly underlined by qualities in the voice of the narrator."

"Suggesting that the unrequited male and the narrator were connected in some essential way. I presume the narrator was the artist. And do we know his name?"

"Brian 'Dawn' Chalkley, Holmes. ARTLAB had arranged for him to perform his piece as a special event for the opening night."

"Why did you say the names Brian and Dawn together in that way?"

"Because, as I understand it, his name is Brian, but when he dresses up as a woman, as he does on occasion, he likes to be known as Dawn."

"Which brings us back to Mary Ann 'George' Eliot."

"Does it, Holmes?"

"Or rather it brings us to G H Lewes, the man with whom George Eliot lived from 1854 until his death in 1878. Their union could not be regularised because he had condoned the adultery of his existing wife Agnes to another man with whom she went on to have four children."

Watson didn't know if it was Holmes' intention for the scene on the table in which the woman was being made love to by several lust-filled men to come to his mind, while another man stood back in the shadows, but certainly that's what had happened...

"Now this G H Lewes was a curious fellow, Watson. Before meeting George Eliot (by the way Lewes' own first name was of course George) he was a comic dramatist, a versatile actor, and an essayist on subjects ranging from Hegel's aesthetics to Spanish drama, and – note this particularly Watson – the author of a novel in imitation of the German master Goethe. After his liaison with George Eliot began in 1854, Lewes apparently turned to science, and published books on biological and physiological subjects. An ambitious series of books on psychology, *Problems of the Mind*, appeared from 1873 to 1879, with the last volume *being completed by George Eliot* after his death."

"What are you saying, Holmes?"

"Nothing yet, Watson. Merely stating some relevent facts which I made myself aware of this evening when you were out enjoying yourself. Let us turn now to certain biographical information concerning George Eliot. She wrote nothing of significance before the liaison with Lewes. Some stories started to appear in periodicals in 1857. *Adam Bede* was begun in 1858, *The Mill on the Floss* appeared in 1860. *Silas Mariner* in 1861. *Felix Holt, the Radical* appeared in 1866, *The Spanish Gypsy* in 1868, *Middlemarch* in 1872 and *Daniel Deronda*, her last major work, in 1876."

"So she didn't write any significant fiction either before she met Lewes or after he died. It's a terrible thought, Holmes, but could it be that this George H Lewes is the person responsible for the great books that flowed from the pen of George Eliot?"

VOLKER EICHELMANN / ROLAND RUST *Martello Towers #09*

"Oh, I think George Eliot actually wrote the books, Watson, so many of which were a tribute to an independent-minded man. But there is the matter of who conceived them. Our own working partnership comes to mind. There is no question that you wrote *The Hound of the Baskervilles* and are responsible for *The Casebook of Sherlock Holmes*. But I think you would admit that the books would not exist without my own participation."

"Absolutely, Holmes. I am no more than your dutiful scribe. Do you think that George Eliot had the same role in… "

"This is tricky ground, Watson. If I'm not careful I'll be accused of saying that books attributed to a great female writer were really the work of a man.

But rather I'm saying that the unquestionably huge talents of a man were made available to George Eliot, another individual of unquestionably huge talent. Just as, in reverse, the unquestionably huge talents of women, first Roxy Walsh, and then Charlotte Cullinan and Jeanine Richards, have played a supporting role in allowing the unquestionably huge talent of Brian Chalkley to flourish."

"Don't forget Dawn."

"I'm not forgetting Dawn. But I'm not losing sight of my search for the real George Eliot either, Watson. And what better place to find her than in the very core of her great novel, *Middlemarch*. I would be grateful, Watson, if you would open the book and read from the top of the page I have folded down."

"I'd be delighted to do that for you, Holmes." Watson takes up the book, finds the page in question, and reads: "'You approve of my going away for years, then, and never coming here again till I have made myself of some mark in the world?' said Wil, trying hard to reconcile the utmost pride with the utmost effort to get an expression of strong feeling from Dorothea."

Sherlock interrupts: "An experiment Watson. As you read on, kindly replace the name 'Dorothea' with 'George', and the name 'Wil' with 'Lewes'. That should help clarify what we have here."

Watson continues: "'She was not aware of how long it was before she answered. She had turned her head and was looking out of the window on the rose-bushes, which seemed to have in them all the summers of all the years when Wil – sorry, Holmes, Lewes – would be away. This was not judicious behaviour. But George never thought of studying her manners: she thought only of bowing to a sad necessity which divided her from Lewes. Those first words of his about his intentions had seemed to make everything clear to her: he knew, she supposed, all about Mr Casaubon's final conduct in relation to him, and it had come to him with the same sort of shock as to herself. He had never felt more than friendship for her – had never had anything in his mind to justify what she felt to be her husband's outrage on the feelings of both: and that friendship he still felt. Something

which may be called an inward silent sob had gone on in George before she said with a pure voice, just trembling in the last words as if only from its liquid flexibility –'Yes it must be right for you to do as you say. I shall be very happy when I hear that you've made your value felt. But you must have patience. It will perhaps be a long while.'

Lewes never quite knew how it was that he saved himself from falling down at her feet, when the 'long while' came forth with its gentle tremor..."

"Spit on the book, Watson."

"What?"

"Spit on the book."

"Why?"

"Because I ask you to."

"I can't spit on the book, Holmes. It's beautiful."

"Spit."

"No."

"Spit."

"No."

"Spit, Watson!"

"Never, Holmes!"

"Very well," says Sherlock, suddenly looking pleased with the way things were turning out. "Then read on from the top of page 683."

"Aloud?" says Watson, his hand shaking as he turns to the relevant page. It had not been easy for him to go against the five-times stated wish of the great detective.

"How else will I hear the words, my dear friend?"

Watson pulls himself together, clears his throat, and reads: "'I have never done you an injustice. Please remember me,' said George, repressing a rising sob.

'Why would you say that? said Lewes with irritation. 'As if I were not in danger of forgetting everything else.'

He had really a movement of anger against her at that moment, and it impelled him to go away without pause. It was all one flash to George – his

last words – his distant bow to her as he reached the door – the sense that he was no longer there. She sank into a chair, and for a few minutes sat there like a statue, while images and emotions were hurrying upon her. Joy came first, in spite of the threatening rain behind it – joy in the impression that it was really herself whom Lewes loved and was renouncing, that there really was no other love less permissible, more blameworthy, which honour was hurrying him away from. They were parted all the same, but – George drew a deep breath and felt her strength return – she could think of him unrestrainedly. At that moment the parting was easy to bear: the first sense of loving and being loved excluded sorrow. It was as if some hard icy pressure had melted, and her consciousness had room to expand; her past was come back to her with larger interpretation. The joy was not the less – perhaps it was the more complete just then – because of the irrevocable parting; for there was no reproach, no contemptuous wonder to imagine in an eye or from the lips. He had acted so as to defy reproach, and make wonder respectful."

"Spit on the book, Watson."

"I am not even going to dignify that with a reply, Holmes!" says Watson, who was by now siding very definitely with George Eliot. 'The first sense of loving and being loved' what a beautiful sentiment! But hard on its heels came the two strongest images that he'd been confronted with earlier in the evening. First, the man who wanted to be buggered by a group of anonymous men, standing sad and alone. Second, the man who had lost his leg and his arm and his arse and his pecker and his bladder, singing *Pack up your troubles in your old kit bag*... How did the 'loving and being loved' words stack up against those negative images?

"Spit on the book Watson."

Watson does not spit on the book. But the image of Brian 'Dawn' Chalkley comes to mind. Or at least that poor man alone in the wood. An unhappy man, conscious of his unhappiness. Suddenly Watson does spit on the book. His eyes widen and he looks at what he's done in amazement. "Oh, my God. Forgive me, Holmes."

"Don't worry about wiping it. Close the book, Watson. Or rather turn to page 867 and begin to read from the top once more."

Watson turns the pages with a sense of foreboding. He has no idea how he is going to react to what he is about to read. The only thing he knows is that he on George's side, on Brian's side, on the Ulsterman's side, and he is not – repeat, not – going to let Holmes have things all his own way. Watson reads:

"They stood silent, not looking at each other, but looking at the ever-greens which were being tossed, and were showing the pale underside of their leaves against the blackening sky. Lewes never enjoyed the prospect of a storm so much: it delivered him from the necessity of going away. Leaves and little branches were hurled about, and the thunder was getting nearer. The light was more and more sombre, but there came a flash of lightning which made them start and look at each other, and then smile. George began to say what she had been thinking of.

'That was a wrong thing for you to say that you would have nothing to try for. If we had lost our chief good, other people's good would remain, and that is worth trying for. Some can be happy. I seemed to see that more clearly than ever, when I was the most wretched. I can hardly think how I could have borne the trouble, if that feeling had not come to me to make strength.'

'You have never felt the sort of misery I felt,' said Lewes; 'the misery of knowing that you must despise me.'

'But I have felt worse – it was worse to think ill... ' George had begun impetuously, but broke off.

Lewes coloured. He had the sense that whatever she said was uttered in the vision of a fatality that kept them apart. He was silent a moment, and then said passionately:

'We may at least have the comfort of speaking to each other without disguise. Since I must go away – since we must always be divided – you may think of me as one on the brink of the grave.'"

On impulse, Watson decides to read the next bit in an Ulster accent. A feeling had been building up within him that that wouldn't be inappropriate:

"'While he was speakung there came a vivud flash of lightning which lit each of thum up for the uther – and the light seemed to be the turror of a hopeless love. George started instuntaneously from the window; Lewes followed hur, seizing hur hand with a spasmoduc movement; and so they stood, with their hands clasped, like two chuldren, looking out on the storm, while the thunder gave a trumendous crack and roll above thum, and the rain began to pour down. Then they turned their faces towards each uther, with the memory of his last wurds in them, and they did nut loose each uther's hands.'"

Yes, that hadn't made any difference, really. But it did make Watson feel extra sad, so he went back to his own reading voice:

"'There is no hope for me,' said Lewes. 'Even if you loved me as well as I love you – even if I were everything to you – I shall most likely always be poor: on a sober calculation, one can count on nothing but a creeping lot. It is impossible for us ever to belong to each other. It is perhaps base of me to go away into silence, but I have not been able to do what I meant.'

'Don't be sorry,' said George, in her clear tender tones. 'I would rather share all the trouble of our parting.'

Her lips trembled, and so did his. It was never known which lips were the first to move towards the other lips; but they kissed tremblingly, and then they moved apart.

The rain was dashing against the window panes as if an angry spirit were within it, and behind it was the great swoop of the wind; it was one of those moments in which both the busy and the idle pause with a certain awe."

Actually, what Watson could try now was a bit of a trick. For George he would substitute his own name, and for Lewes' name, Holmes.

He reads: "*Watson* sat down on the nearest seat to her, a long low ottoman in the middle of the room, and with her hands folded over each other on her lap, looked at the drear outer world. *Holmes* stood still an instant looking at her, and laid his hand on hers, which turned itself upwards to be clasped. They sat in that way without looking at each other, until the rain abated and began to fall in stillness. Each had been full of thoughts which neither of them could begin to utter."

"Watson *what* are you doing?"

"Oh, just an experiment, Holmes. I'll desist if it troubles you."

"Desist, then."

Watson reads: "But when the rain was quiet, George turned to look at Lewes. With passionate exclamation, as if some torture-screw were threatening him, he started up and said 'it is impossible!'"

Watson considers for a moment substituting the names Dave and Bob for George and Lewes, but reckons that would only irritate Holmes again. So Watson reads:

"He went and leaned on the back of the chair again, and seemed to be battling with his own anger, while she looked towards him sadly.

BRIGITTE JURACK *Boat House (Liverpool); Covered Market (Kiev)*

'It is as fatal as a murder or any other horror that divides people,' he burst out again; 'it is more intolerable – to have our life maimed by petty accidents.'

'No – don't say that – your life need not be maimed,' said George, gently.

'Yes it must,' said Lewes, angrily. 'It is cruel of you to speak in that way – as if there were any comfort. You may see beyond the misery of it, but I don't. It is unkind – it is throwing back my love for you as if it were a trifle, to speak in that way in the face of the fact. We shall never be married.'

'Some time – we might,' said George in a trembling voice.

'When?' said Lewes bitterly. 'What is the use of counting on any success of mine? It is a mere toss-up whether I shall ever do more than keep myself decently, unless I choose to sell myself as a mere pen and mouthpiece. I can

see that clearly enough. I could not offer myself to any woman, even if she had no luxuries to renounce.'

There was silence. George's heart was full of something that she wanted to say, and yet the words were too difficult. She was wholly possessed by them: at that very moment debate was mute within her. And it was very hard that she could not say what she wanted to say. Lewes was looking out of the window angrily. If he would have looked at her and not gone away from her side, she thought everything would have been easier. At last he turned, still resting against the chair, and stretching his hand automatically towards his hat, said with a sort of exasperation, 'Good-bye.'

'Oh, I cannot bear it – my heart will break,' said George, starting from her seat, the flood of her young passion bearing down on all the obstructions which had kept her silent – the great tears rising and falling in an instant: 'I don't mind about poverty, I hate my wealth.'"

"You know what to do Watson."

Watson doesn't know what to do. So he reads the passage again in an Ulster accent:

"'*Oh, I cannut bear it – my heart wull break,' said George, starting from hur seat, the flood of hur young passion bearing down on all the obstructions which had kept hur silent – the great tears rising and falling in un instant: 'I don't mind about poverty, I hate my wealth.'*"

"Spit, Watson," repeats Holmes.

Under pretence of gathering spittle in his mouth, Watson secretly reads on to the end of the page. "In an instant Lewes was close to her and had his arms round her, but she drew her head back and held his away gently that she might go on speaking, her large tear-filled eyes looking at his very simply, while she said in a sobbing childlike way, 'We could live quite well on my own fortune – it is too much – seven hundred a year – I want so little – no new clothes – and I will learn what everything costs.'"

"What are you waiting for? Spit, Watson."

"No, Holmes. Listen to this. '*In un instant Lewes was close to hur and had his arms round hur, but she drew hur head back and held his away gently that*

she might go on speaking, hur large tear-filled eyes looking at his very simply, while she said in a sobbing childlike way…'"

"Spit, Watson."

" '*We could live quite well on my own fortune – it is too much – suven hundred-a year…'*"

"Spit, Watson!"

" '*– I wunt so little – no new arse…*' "

"Damn you, spit, Watson."

" ' *…und I wull learn what a new pecker costs.*'"

"By the sacred memory of George Eliot, I order you to spit, Watson!"

Watson spits. Then considers what a bloody mess he has made of the beautiful old book.

Meanwhile, Sherlock presses home his advantage: "Watson, Watson! What on earth made you want to denounce in such a puerile way the climax of such an emotionally intelligent – such a spiritually transcendent – book and exhibition?"

Watson would have liked to reply, but it had been a long wet evening, a long long night of driving wind and relentless rain. He was absolutely fucked, and didn't he just know it.

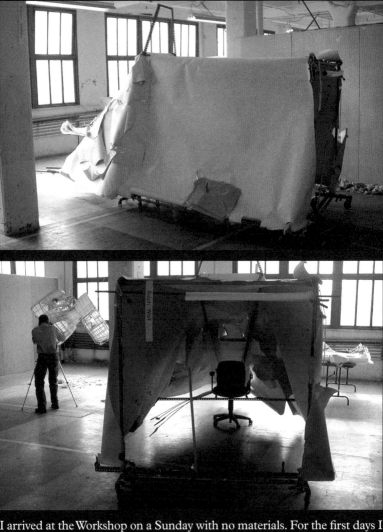

I arrived at the Workshop on a Sunday with no materials. For the first days I drew the cast shadows on my 16 foot wall. Wanting to get away from myself, I began signing my name with a stick whose length gradually increased to a distance where the signature was unreadable.

A Chameleon in the Valley

FABIAN PEAKE

black sun rises up one end **medieval grille** mausoleum
smooth wood blocks my father drew the hand that painted the
coming of day **and the lady sits reading** a snake was under the
written stone **and in the dark place the lines undulate** voices
against voice **looks out from curls of ink** the soul breathes in the
voice of a believer **the point was touched** I make bags with
holes **you're offset** the soul is behind the box **the woods**
people look behind the box sort of toy crowns for giants **these**
flags don't flap in the wind Narcissus looks at Korea **could be a**
wind sock basin **drone** not a Scottish air but a thing about a
mistaken heartache **while you look at blue and yellow snow voices**
return roll round in a hamster's wheel **an unfinished what?**
ffour vvoice bboxes **rolled up voices** the camera goes round and I
see I am a man **we saw them in Scotland on their leck** frayed
hairstyles without a clutch of turquoise eggs **dragonfly's wings cut**
twice

… ardour ….. ardour ……. ardour ..

.. ardour …. ardour …. ardour ..

ardour …. ardent …. ardour …. ardour

… ardent …. ardour ….. ardour …..

.. ardour …. ardour …. ardour .. I'

.. .. ardour ….. ardour ……. ardour ..

.. ardour …. ardour …. ardour ..

ardour …. ardent …. ardour …. ardour m

… ardent …. ardour ….. ardour …..

John washed his body from head to coccyx when he awoke on the first day
of his sojourn in Gibraltar. It was demanded that he be odourless for the
task he was to perform. His orders were plain – he should search the
shoreline for shells bearing a text in miniature handwriting on their inner
surfaces. The script would be indecipherable to John; it was necessary only
that he should find the shells. When seven prime examples had been
gathered, he should return to the base with them, wrapped carefully in
seaweed. His commander would reward him with a kiss. c

{Just take the word 'yellow' and add water}

risotto rice *The old masters had only the very poisonous* a
bread *orpiment, yellow sulphide of arsenic, and realgar, arsenic*
salad *orange (arsenic disulphide), to work with. It was*
washing up liquid *very coarsely ground and applied with tempera. In*
washing powder *oil painting it was used pure without admixtures*
Guardian *between layers of varnish. In Pompeii it has*
oranges *frequently been discovered in ochres, but it has*
onions *also been traced in present-day cadmiums.*
lavatory cleaner
tuna l
blackmail l

A few popes. i

St. Linus 67–76
St. Hyginus: 136–140 n
St. Soter: 166–175
St. Eutychian: 275–283 There was a time when we boys
St. Hilarius: 461–468 ran round the field for 'chocolate'.
St. Hormisdas: 514–523 g Quick runners had none; they
Boniface II: 530–532 always laughed at the lack.

 Would the great traveller, St. X.,
 have swung the stick at the end
 of the race if he'd been there?

A few kings. Are you asking me to sprinkle lime
 in his coffin; pinch his left leg; shave
Egbert: 827–830 his ever-fruitful beard?
Ethelwulf: 839–857
Ethelbald: 857–860 His blood still flowed three months
Ethelbert: 860–866 later, but before that he'd rolled up f
Ethelred: 866–871 his sleeves and cured the plague.
Alfred the Great: 871–899 Such stories are gospel in Goa.
Edward the Elder: 899–925

o

The moorland exhaled a fresh mauve breath as the summer dawn rose. On the horizon, a figure became visible, striding purposefully in my direction. Although several hundred yards off, I guessed it to be a man. The chill mist, which clung here and there to the bracken, occasionally enveloped him. As he advanced, he swiped restlessly at the vegetation with his stick, and I wondered whether I would know him when our paths crossed.

Momentarily, I became distracted by a loose lace on one of my walking boots and stooped to tie it up. When I resumed an upright position the walker had evaporated, as though swallowed whole by some vaporous hell-hound. r

Why had Frank Boscombe's name muscled into my consciousness? He'd been a friend from my days on the island with whom I'd lost contact. But I knew him to be dead. A cold ripple ran up my legs as I y

The very shadows assumed the colours of their mothers.
The very shadows assumed the colours of their mothers.
The very shadows assumed the colours of their mothers.
The very shadows assumed the colours of their mothers.
The very shadows assumed the colours of their mothers.
The very shadows assumed the colours of their mothers.
The very shadows assumed the colours of their mothers.
The very shadows assumed the colours of their mothers. o
The very shadows assumed the colours of their mothers.
The very shadows assumed the colours of their mothers.

Describing the nutritional requirements for the weekend fishing trip
when he returned, Michel surprised everybody, even his ageing
mother, by divulging the extraordinary patterns of thought
expounded by the rest of the group when questions were put to them
challenging their outlook on piscatorial death. u

He was known as an awkward man, *Contrary to popular opinion,*
The Painter; even his daughter told us so. *the farmer rose from his bed*
(You are not needed; don't expect smiles). *at five o'clock in the morning.*
While the world celebrates D-Day *He was a man of routine and could not rest*
he languishes where someone has placed *until he had counted every last one*
him, behind the sink's knobbled tap. *of his decorated porcelain eggs.*

G

There, he dreams himself in Cadmium red; in bed *His was the only comprehensive set*
as usual, smoking as usual, naked bulb burning. If *of Calitrant de Mercy's stupendous*
piled boots were part of his dream and the plate *inventions. The farmer kept*
of biscuits a snack for now, nobody would know. *the de Mercy collection secreted*
All that can be said is that they are there, and *in the depths of his cellar. Each egg was*
his midnight story re-told at the corner of time. *elaborately documented in a*

She sailed this side

e of the ancient stone wall,

tacking back and forth
in her fibreglass dinghy.

There were no thoughts
for the walled-up country

of her own ignorance.
Over that ivy-festooned barrier

o scurrilous mumblings failed
to reach her muffled ears – 'She

doesn't know of red romans,
those hairy, ten legged creatures'.

The bursting rooms of velvet
obliquely held their tongues.

r

It was on one such occasion that Bernard Turnstope began his consideration of Ignorance. A shift in his outlook had brought him to the realisation that it was an unusually variable and absorbing subject. He surmised, "All people are incapable of knowing everything and ignorance is only the deficit of knowledge". g

e. *A vast tract of cerebral countryside was opened for Bernard as he began to compare himself to Leonardo da Vinci, Sappho, the stocktaker at Tesco's and the oldest man in the world, Dmitri Sholakovsky. "All their knowledges are different but their ignorance is the same! In that respect, I must be Albert Einstein's equal"*

brian richardson

i said i would walk the pennine way in 14 days but i am
now regretting this decision very badly it is now day 5
and i am cut of from all communication i am just past
malham, my mobile as no signal i am wet though today
hasn't been so bad but for the rest of the week it as
been dreadful. i hope to see you all at the library very
soon god i miss you but i will keep in touch by the e-
mails oops fell down a hole again ow a wet one the water
has come right over my wellies agh missed it there goes
another sheep it could have dried out my wellies.i need
a drink there a pub i run and run my wellies sloshing
from the overflow,was it the water or was it my bladder
it could have been either i am getting on a bit.anyways
im still running the pub getting closer closer i can
smell my timothy taylors that i havent had for 5 days
its their im touching it no i shout its a mirage like i
had in 1922 fighting in the dessert left all alone even
by my comrades maybe then they knew or i knew i was just
destined to be alone.A lady walks past it is a figment
of my imagination or is it i dont even trust my own mind
anymore it was im sure iwalk faster they walk faster im
catching. thats where it ends until next time to the
further adventures of richieson

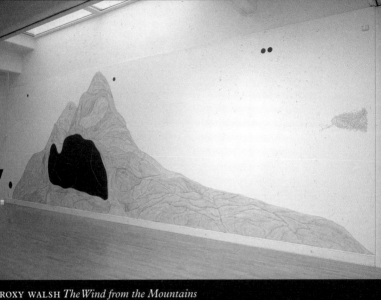

ROXY WALSH *The Wind from the Mountains*

DIEGO VELÁZQUEZ *Las Meninas*

EVE SUSSMAN *89 Seconds at Alcázar*

A Short Story by Davida Pendleton

ADRIAN RIFKIN

Could I really begin to think of myself as Dorothea? It would be on the safer side by far for me to be Daniel, but in any event, I have no right to think of myself as being Dorothea in the way, say, that Gustave thought of himself as being Emma, as he was at least in a position to know this, having made her for this reason, leaving me with the lower, readerly task of empathising with the object that Emma had made of herself for the attentive reader. I will therefore set about the more appropriate course of action, and rather than suffer in my own way Casaubon's attentions, however they might get me out of the house and round some of my preferred cities, simply because *men can do nothing without the make-believe of a beginning… even Science, the strict measurer, is obliged to start with a make-believe unit…* I will now settle for Daniel, and I will try to bring him into being for me, towards me as expeditiously as I

possibly can *…DEAREST CHILD, – I have been expecting to hear from you for a week,* I don't know how this involuntary uttering will get any nearer to him, it's not at all how I intended to start or to set about starting on my approach, and as far as things go on my journey, I don't even know to whom I might be addressing these words. They clearly are not destined for him, certainly not as I want him to be, my dearest child, my other brother lover Jew, for example, just for a start. There is no one I know, to the best of my conscious knowledge, whom I would address in this way, so I rest with this small certainty, that of its being a *pity that Offendene was not the home of Miss Harleth's childhood, or endeared to her by family memories,* though had this not been a certainty, this pity or this not being, for me or for Miss Harleth, or just for the story, I myself might well have been able to enter it from a slightly different angle, rather than taking it as it

was now set down before me, by George Eliot herself, no less!. But I will be compelled to take this path, the path of the text, and in what we winningly call its textuality, to try to give it something of all of those '-itys' that seem most vital to me and, indeed, for me in this strange age when '-itys' in all their pullulating forms have succeeded the '-isms' of my youth. So then, it must be – here and now – perfectly true for me, whatever else I might want to believe, that *it would be a little hard to blame the Rector of Pennicote that in the course of looking at things from every point of view, he looked at Gwendolen as a girl likely to make a brilliant marriage.* It was never my intention to blame anyone in this matter, other than myself for wanting Daniel, nor indeed, and by the same token, to become so involved with Gwendolen, even less, for that matter, with the knowledge that *that lofty criticism had caused Gwendolen a new sort pain.* A new sort of pain is necessarily no bad thing on a certain path to learning, if the balance of the intensity and the newness is properly held in play. Here I can get involved, I might snuggle in along-side a certain sadism in the subtext, a certain subjection of learning and its pains, the learning of moving across the surface of the text itself, and learning of it and from it at one and the same time, this is a pain of not settling, of not finding him spring to my eye after so many, already so many chapter headings and first lines. It is indeed a bit like looking at an image, either one that moves and escapes us, or one that stays perfectly still and escapes us nonetheless, in the end it makes really no difference whether time is in the medium or in us provided it is in both. Absorbed now, a little un-nerved, as I don't even know what that lofty criticism had been as I make my own text and so make it in terrible ignorance of the stake, of the sort, you might say, the out-come, and so it's a source of deep comfort and relief to see something so evident, limpid and simple as that *The first sign of the unimagined snowstorm was like the transparent white cloud that seems to set off the blue,* although even in that very moment of an epiphanic coming to rest, of seeing one thing clearly through another, there is little that

does not remind me that it is not yet him whom, that, I see clearly, and even that would be as if through nothing else but directly; I knew too that *There was a much more lasting trouble at the Rectory,* for, *Eight months after the arrival of the family at Offendene, that is to say in the end of the following June, a rumour was spread in the neighbourhood which to many persons was a matter of exciting interest.* Apparently this had *no reference to the results of the American war,* and hence kept me from using my broader political knowledge to engage with this oh so closed community, but it was one *which touched all classes within a certain circuit* round which, I have to say, I myself have no control whatsoever, within which I cannot place myself, any more than he can, and so there we are, in the same wider space if certainly not side by side. *Brackenshaw Park, where the Archery Meeting was held, looked out from its gentle heights far over the neighbouring valley to the outlying eastern downs and the broad slow rise of cultivated country hanging like a vast curtain towards the west.* Nothing here but another reminder how I, set apart from all of these social rounds, a stranger to them, may never hit my own mark, while, on the other hand, with all his mastery of the elaborate codes and rituals of that circle, and having the grasp that he does within the real, while I am merely beside it, a supplicant at its very figment, *Grandcourt having made up his mind to marry Miss Harleth showed a power of adapting means to ends.* How much longer shall I have to see this through, this deprivation, privation partial images, this part figuring, non-figuring, appearance on the lips of others, in the title, but nowhere that I can find him, how much longer shall I have to hear how *Gwendolen looked lovely and vigorous as a tall, newly-opened lily the next morning:*, or other maudlin commentaries on the fortunate but eventually vapid person, when even, in comparison to her, I would rather be by Dorothea's side, for surely I made the wrong choice when, in comparison to Dorothea, *Gwendolen, we have seen, passed her time abroad in the new excitement of gambling, and in imagining herself an empress of luck, having brought from her late experience a vague impression*

that in this confused world it signified nothing what any one did, so that they amused themselves. Surely, for me, I cannot adapt my means to my ends, hardly at all, until then, there without my trying or expecting it, I now find out, rather at the last breath, and just as I am about to give up altogether, that *Deronda's circumstances, indeed, had been exceptional* and, moreover that, towards the *end of July, Deronda was rowing himself on the Thames.* Although I have myself, at one time or another, been rowing, though not on the Thames, but on Regent's Park Lake, or that in Platt Fields in Manchester, and though I have been punting on the Cherwell, and seeing that I was led to believe that this novel is especially to do with the matter of the Jew, I had never thought of this as an especially Jewish thing to do, despite it being something that he and I have both done. *Mrs Meyrick's house was not noisy: the front parlour looked on the river, and the back on gardens, so that though she was reading aloud to her daughters, the window could be left open to freshen the air of the small double room where a lamp and two candles were burning,* did this concern them, these daughters as they listened, the splashing of Daniel's oars? In any event *To say that Deronda was romantic would be to misrepresent him; but under his calm and somewhat self-repressed exterior there was a fervour which made him easily find poetry and romance among the events of everyday life,* so maybe he was conscious of the way the lapping sounds might have invaded their candle-lit consciousness, and, at the same time, could relish how *Gwendolen became pallid as she listened to this admonitory speech,* the full phenomenological force of *the ideas it raised had the force of sensations,* despite my own now bitter sense of separating myself from any sensation of him, from him, even for him. For oddly, it seems, so typical of his time, from his not being able to be what I want him for as my projection. For in *Spite of his strong tendency to side with the objects of prejudice, and in general with those who got the worst of it, his interest had never been practically drawn towards existing Jews, and the facts he knew about them, whether they walked conspicuous in fine apparel or lurked in by-streets,*

were chiefly of the sort most repugnant to him. And yet here we are, he is exactly like me as well, in the fictions that I spin around my own lay self in the depths of the twentieth century of wars that never wants to end just to respect the years after 2000, unless it is to inaugurate another millennium of wars, for *Of learned and accomplished Jews he took it for granted that they had dropped their religion, and wished to be merged in the people of their native lands.* But in the end, it is far too late.

DP 2004

MARK FAIRNINGTON *Cape Hunting Dog*

The Undoubtedly True Story of Lips de Mer

ROMMI SMITH

Fishnets. Evil things. Urghhh!
Darlin', I catch sight of some broad's
dainty-heeled legs, captured in
those thick jet threads and
the same night, I'll dream in
nightmares. Lucifer. George Bush.
Here, sleep is a language
of mirrors, each one reflecting
fear. Contagious

memory sees a cloud of silver,
torn out from the deep-blue picture
of the sea. I am a brushstroke
in the Master Painter's creation,
until the Devil hauls a shoal of us
in his net, up, out, through to earth,
the sky of the ocean. I,
seriously think I've died.
Hell. That Neptune has called time
and decided I'm to live
on the Other Side.

On what I now know is, 'The Deck',
I first hear the foreign language
of the devil's henchmen: grunts, growls,
shouts, yells. Honey, I'm not ashamed
to say – I piss myself. I am not alone.

Each sentence of every cautionary story,
from the mother-tongue
of my grandmother's imagination,
runs its extent across the full length
of my body.

Since then, an LA shrink diagnosed,
Post-Traumatic-Fished-Phobia,
characterised by, a fear of heights;
a desire to be loved, but
a fear of being close;
an escapologist's lust to cut loose
in tight spaces.
Lifts?
Forget it.

Anyway, sugar, before I blink,
next thing, I'm on some restaurant
version of Death Row. Swimming
my death sentence round in circles
in a glorified fish bowl,
waiting for some fat cat to
pick my plump ass to be sliced,
battered, deep-fried
and served with English fries,
lemon wedge on the side. Nice.

Chico, darling, get me another gin,
on ice?

Anyhow, this is the bit,
that made Steven himself,
want to direct:
It's 1938, a plastic surgeon, Doug
and his wife, Do'reen,
are out celebrating
their Silver Wedding.
Twenty-five years together;
a different kind of death sentence,
some think. Meryl Streep
would play me, if you're asking.

Do'reen stares through the glass
and is captivated by the sight –
sorry, I get misty-eyed every time
I tell this part. She looks deep
into my eyes, my throbbing soul
sending psychic currents
rippling through that fish bowl
'til she cries,

Doug, sweetie, that cod can't die!
Doug, baby, look at those **lips**,
those doe-ray-me-eyes.

Waiter, we'll get that one to go! Live.

In my new home, a mansion
in what the hacks call Tinsel Town,
in my Chanel robe with my name embroidered on:
Lips de Mer, (Lips for short),
Doreen would coo, 'bird-lipped women
would kill for lips like you'.

Doug was planning experiments
to grant every starlet's wish:
bigger breasts, bigger butt,
lips like a fish…

Well I'm no martyr, sweet pea,
but I couldn't refuse being
model and muse. And you
can put this in capitals, honey:
Joan Rivers would be NADA,
without moi.

Life was one long bar and I paraded them all
with my long-gloved shadow called intrigue.
I drank old scotch with dignitaries, blew
gin coloured kisses for presidents,
translated my lips into contracts with agents.

I met the casting couch and stared
it out. Jesus, what man didn't look
at these lips and rise to the occasion?
Darlin' is that a script in your pocket,
or do you think I'm easy?

ANNIKA SUNDVIK *Fish*

I took a younger man.
Purr. Ignored whispers of fad,
red herring, freakshow. The bright lights know
I sang with Frank, once.
His blue eyes made me
homesick.

Fred – well, at Carnegie, I danced him out.
And I got mad at the world when it never wrote that down,
especially as the fact is that I did
everything he did, but backwards
and with fins.

What gets me, really galls me now,
the Welfare people don't respect
my autograph. The kids across the
block play ball, call out my given name –
old trout. I wouldn't mind, I'm a cod,

but
we're apt to start believing what the world
thinks of us.

There was a glimmer of hope.
God, an agent tracked me down to front an ad campaign –
to sell a product for discreet, intimate hygiene:
Gentle. Summer. Breeze-fresh.
One receiver click and she was gone.
Mama would have turned in her seabed.

Sweet thing, TV keeps me company these days.
Whole channels devoted to
folks rewriting what God gave.
Living, breathing, walking, eating fictions;
skin stories with no financial reason for an ending.

I'll catch a collagen injection, live
and pour another glass of sherry, red wine,
paint my lips rouge and laugh out loud.
Point to the poor cow and think,
cow ass! Sweet-heart, these lips came for free.

Steven's PA, always says he's busy...

My nightcap is the nature channel.
After, I'll dream of long-lost friends,
dolphins, whales, right behind them,
like a long-tailed never owned translucent dress,
the shoal of offspring
I never had.

through further rooms, and yet further, counting. And, back. It's not there. It is lost.

Staring unmoved at this, Till thought to rearrange things until things could be settled. The settee, he pulled out of the room altogether, and pushed it up in front of the fireplace of the next room. A small table, he simply shifted by a fraction of an inch to square it off. He moved a rug to cover the spot where the settee had been. He looked up to find the next adjustment. Jo ho he jo he! ho-he, hohohe, hohohe! Martial merriment slipped into his soul again. Purpose and order. If this could supress the loss of the line, perhaps he could see a new occupation ahead of him, a role, a suitable place, appropriateness and decorum. He sat again. The rapidity of the calamity, and its resolution had wearied him more than he could imagine it would have. In dozing, he found himself in a street, behind him a building, an industrial building. In front of him a link fence, bellied out by football. Yellow lines on the floor, becoming faint and grey, washed tar-stained gravel. Unspeakably clean, unused. In his hands two pieces of wood, one damp, almost rotten. Both were bound to each other with tape. Clear tape, enormous and abundant and excessive amounts of clear tape, crinkling with a texture all of its own. He started, as he knew he must, to pick.

On the immaculate, pristine, sweetly perfumed kerbstone to his left, sat the tiny, tiny coffee cup, which he had always known to be on its side. It rolled slightly in its saucer, as it always did. He reached to turn the dial to 'Full' on the gas fire. Its features were approximate, doll's house approximate. There was heat, but the flame was painted, maybe some kind of transfer, perhaps. He turned again to his picking. This piece was coming off easily, with a constancy and grace rarely afforded by adhesive tapes of other times and places. But, no. The tape is holding, just occasionally catching, catching enough to worry one, not that it may break, but that it may put one off to such an extent that it may force one to react in an unthinking way, causing some other action that may lead to yet another action that may endanger the tape and its integrity. But, again, all is well, and the tape comes away, comes away, comes away. Comes away, comes away, comes

VOLKER EICHELMANN / ROLAND RUST *Martello Towers #04*

Perhaps it was that the blue and the green and the unorthodox colour of the floor. Yes, the floor, perhaps the floor, or some relation between the colours. No.

There it struck him. One too many lines. Startled beyond words, his hands started to open and close, scratching slightly on the surface of the rich upholstery. He watched himself rise, and walk towards the wall facing him. He had not actually seen the extra line, not yet. His revising mind, combing through the actions of the day, knew that there were one too many, but he had not yet seen it mentally, nor had he been able to put his finger on it. He stood now only inches from the wall, turned to nothing but the expanding and expansive green. He watched himself pace the room counting, his pale and portly fingers folding into his palm, one by one. He counted what there was to be measured, and he counted the measurements. He watched as he left the room, through double-doors into the previous room, still counting. He watched as he walked, almost sleeping,

VOLKER EICHELMANN / ROLAND RUST *Martello Towers #20*

completed during the day seemed to add up here to a major seventh. There was progression, and there were rooms to come, and it may change as he reviewed things, but for the moment, no, he was sure.

It was the coarseness of this realisation of the day that had unsettled him. He pursed his lips in a vinegary pause: "blues". The word stepped out in front of him, shook itself, and defied him. Till sniffed. He looked away. Now the size of the numerals concerning him. Fifteen feet, three and three eigths inches, in numerals precisely two and three quarter inches high, with always the same constant degree of slope, and always the same character and gravity to them. With each line exactly four inches from the floor, ceiling or proximate wall or door frame, each measurement was exactly two inches above, below, or to the left or right. He had once had a system for this, a set of rules. But these had become ingrained, and now he just knew what to do. He would not like to be called upon to demonstrate his system though, and he did his best not to think of it anymore. Were the numerals too small? No.

Salted Pleasures

ROB STONE

I.

Till sat. And sat, and patted the cushions, and sighed. He brushed dust from his knee, and sat. He shot his cuffs. Calling on his collected dignity, just in case he should be surprised, he looked in a studied way over his shoulder. Fixing on a point to the left of the door, he struck an attitude so as to be able to slip his eye away should it be caught by anyone entering. It allowed him to pretend a civilised and distracted ignorance, if he needed it.

Measuring the room had taxed his reserves. But it was finished, and the long lines and the numerals were in place, candidly worrying the walls with their brightly smiling pin-pointedness. He was nevertheless anxious, and he would liked to have washed his spotless hands. For the lines he'd used a dryish kind of brush, not a stencil or a pen, or any kind of ink, or tape or string. For the paint he'd chosen an elegantly subdued kind of blue, that he had seen before. More of a turquoise really, but not so outspoken. It sat, with its many nuances, over the mottled and muddy relief of the viridian walls. The lines had their own character. As straight, from a distance, as a spirit level permits, from close up they seemed broken and about to leap off in another direction. From close up, they seemed confused. He smiled.

There were few comparable intimacies for him. His folding rule, his brush and small pewter pot, his level and himself, and the rooms. He thought of the lines sometimes as little snares, and the numerals as some deliciously unfailing arithmetic. This practice of measuring and marking in blue. He could find, hope or dream no terror in it. Only repletions. Sometimes, at this point in the day, he was amused to think of the rooms musically. This one was, he thought, a major seventh. Not because of any sentimental guess-work, or spiritual insinuation, but because of the proportions. The mathe-matics of this room, and those of the three differently scaled rooms he had

away. Oh! No, still fine. Comes away, comes away, comes away. He needed to bundle this, to put it on some kind of reel, to store it and prevent its entanglement with other things – like these numerals, and… he woke.

2.

Having hardly lived a hero's life, his tastes were mild. Boiled sweets and middlebrow brandies, Schubert and the way the ground becomes rust stained at rural railway junctions. The delicacies of hawthorn in flower. He had an architectural appreciation of Lambeth Bridge and the eccentric vanities of old tweed, though he wouldn't admit to either of these. He was a nice old man, and becoming in his way. A pompous, misogynist halfwit, he had been called once, and this had stung. But, he could live up to that when he needed to. He feigned, even to himself, an ignorance of the chill pool of malignity that could too frequently surround him, inhabit his gaze.

His ear, and the euphonies of his singing voice were beautiful once, and still so. A rampaging and licentious past was behind him, but only physically. More than once he had caroused, and terrified a villageful of drinkers. Proud now of his old intimidations, he had become content to loudly exercise his wallet before the well-spoken paupers of the classical record-buying fraternities. His delight in assembling and shattering exhaustive collections of French opera sets, or East German recordings of nineteenth century piano repertoire, was almost entirely aimed at belittling the excitement of these others' wonder at such archival spectacle. Fourteen thousand pounds once spent on a turntable. Fourteen thousand, and still there was a fraction of him which could listen with innocence.

Acquaintances, for there were by now no friends, could recommend him for his skill in showing measured proportion. Though there was no further testimonial for Till, and none that he would value. He refused to admit that he clung to his trade. It was no trade, or a paltry one, and in truth his diffidence turned even toward this single, curiously eroticised pastime. A short brass rule, now redundant given his casual facility with the brush, had been handed to him with hidden ceremony by a declining priest. This one

material treasure, the one thing of no use, the one thing in his life that supplied him with no tangible leverage, was to him a relic. He had been blessed once with a moment of grace in which he was granted a lofty vantage on the world and its workings, and a sense of presence and providence. This rule was the means by which he could remember. Though the once glistening and tremulous panorama he had envisaged, was now forlorn and dessi-

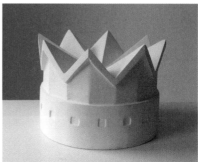

BRIGITTE JURACK *Church (Stralsund); Shop (Plymouth)*

cated, the regularity and precision of the distance between one and another marked inch, or fraction, warmed him. Having no sense of ease with the practice of presence now, this mnemonic to order was what he sought to write large on the national architecture. Turning domestic purlieus into temples, with an artisan's act of measurement, Till sought, with his otherwise clumsy, large and awkward hands, to bring a kind of love to the surroundings of his own cultivated grief.

3.

"I was educated in London." Intellectual ambition, the desire to see himself reflected in achievement, had no longer any consequence. An occasional fervour of charity, and a studious attitude towards every virtuous thing, became the source of acts of appalling generosity. Instructed by seraphs in giving, he gave violently. Wounding with the knowledge he imparted, bullying with fragments of wisdom unfit for further use, the savage harshness of his

instructions for living found their steel in imagined sorrows. "My wife is dead these fifteen years, gone these fifteen years." Far from a blow, her death had been his perfect spur. Claims of loss were precisely what came, spurred forth. This, here, is the habit. " 'Tilding, Tilding', she would say." Manufacturing loss as the place where his life's meaning could assemble, the lost line was just another, plausibly subtle reprise of the contradictions which held him, constellated. His every thought and action forked by the aching towards prophesy, and a dread of an irresistible appeal to the memorial.

The sanity that remained was preserved by his belief in the commission. The grounding fact of another's interest rescued him from obsession and delusion. The economics of this tawdry investment, this frail barricade, this faith in the hallucination that his own repute must secure genuine worth for his work, this economics bore with it a confession of spiteful deceit. Happily, he reversed confessions, accusing others of the very crimes he would commit. "I too," he could begin "have been betrayed." The expanse of his chest, the darkmess of the moustache, even the very shades of the competing browns he wore so workmanlike, each of these spoke of a transparent honour. He was unloaded. He wore conviction with the asperity of biting salts; testing himself as much as the manner of others. Yet he lied. In lending law to the biased, keeping balance for the ineffable, his place, his right to be regarded, pointedly found itself on no principle. He knew, as much as the priest who gave it, that his rule was inaccurate, his measurements improper in ways unknown. Hidden by their revelatory concept, that dominating picture, they would not be tested. The gait, the terrorising acts of giving, his sheer physical volume and the way it was so softly carried, these were his own guarantees. He would not allow himself to know how wrong he had been, could be. Others, they could know of this, he suspected as much, in any case, but the admittance of their complicity, publicly, no, not that.

4.

Tilding looked at his palm. Firmly. He turned it away from his face, reached out, and stroked the surface of the wall. He patted, and stroked

again. It was equally an intimate and expansive gesture. The sensitivity of his soft fingertips found the dints, and with the smallest movements made the loose, the flaking and the dusty, come off. He measured, and with short scrubs of the brush, the line started to appear, realising a cord that he alone could see, and which those who come after will imagine irresistible. The conventional erotics of the paint, the fluidity, the coverage, the neatness and permanence, all of these were absent. The rasping of the brush as it fought to leave trace of its passage, was an image of honest toil, for him. The wall and the brush struggling with each other. "Enough!"

He had long known that the fantastic image of his past, the image that struck him most clearly, and did the most to shade him from the worst of it, was another's. "A blurred and uncontrolled chord of ecstasy." It bothered him that this made him weep. With some esoterically baroque flourish, he returned the brush to its pot. He rubbed one dust dry palm across the other, indicating a pause in a task, and turned to the camera. "The story I am going to tell you is set in the West. Once, on a smallholding in Worcestershire, twelve miles from the nearest town, there lived an engineer with his young wife and their two children, as well as those from his former marriage, two boys, one in his late teens, the other in his early twenties. The first wife had been the daughter of a much loved colleague. Plain in many ways, she had decided that her sons should be called Cassius and Rafe. The boys' stepmother was, rather surprisingly, a different person entirely. Of a vivid turn of mind, she had called her children Lulubelle and Hargreaves. The family didn't keep animals, not even pets, and there was a woman who came in twice a week to look after the youngsters, whilst their mother worked as an architect. Or rather, while she tried to find a paying client for her work as an architect. She spent much of her time polishing plans and proposals she had been working on these past fifteen years.

The house had first belonged to an intriguing, one might say fabulous woman, Beryl, who had married a wounded soldier on his deathbed immediately after the great war. Rural, but never agricultural, she had built this small, unsturdy house. Over the years she had added to it, as a distraction

from the continuing guerrilla actions of her dead husband's complaining family. With outbuildings and additions, and heating systems, one supplanting another over time, the house the engineer bought from her was something of a congeries. It was large, actually it was far too large. At the bottom of a steep incline, maybe three hundred yards away and through a delapidated orchard, was a trickling road, that would soon become a major highway. The smaller road that led to it from the house, was as badly troughed and rutted as it might have been a hundred years ago. In fact, a tank had been driven up there during the second war, and ruined its newly macadamised surface, leaving only refuge for puddles and the dashing scuts. Whoever lived here felt some kind of proprietorial and paternal relationship to these, the most eatable of all rabbits. It was May, and the atmospheric congestions of the cities had brought out the reviled workers in their droves. The engineer's wife, with her hand on her hip and a lip bitten in pale contempt, watched as they drifted to and fro, in twos and tens, hunting one then another farmer's stall, buying strawberries and eggs and the produce of an already tiring spring. Sometimes she would snare and sell the rabbits to them, causing upset in the house.

Looking out from the room that she was proud to call her study, she called to Cassius and Rafe. She asked them to take a turn at cleaning the farm machinery, indolent now as it was. She was careful too, to ensure that it was Rafe and not Cassius who took care of any technical repairs. The rents afforded by these machines were the mainstay of the domestic economy. Naval engineering in this the most land-bound piece of England was a trying life to maintain. And, Rafe was so much more adept than Cassius. On a ragged arrangement of flags, outside the kitchen, Lulubelle and Hargreaves played at harbour. Engineer and architect had easily and entertainingly contrived a small boat on wheels for their children, and Hargreaves hauled on the rope attached to the boat which contained his sister. "We are there!" "What?" "We are there! Splash, splash, it is the sea. We are there!" The engineer smiled the kind of smile that he should whilst watching his children's inventions, and moved off to his own place to stare

at the heap of drawings on his makeshift drafting table. The extension to a dock in Plymouth. He had returned from there only a week ago now, despondent at the scale of the job, the truculence of the site, and the remuneration. Yes, the remuneration. Hardly the right word for the imbalance it described. Out through the window a single brilliant red flower, a poppy, or a peony perhaps, seemed to tear a small hole in the the constancy of the green behind it, and to pour something delightful into the world, like a perfume seen. Then came the squeal, and the thundering of feet as his wife came downstairs, and the enormously resounding smack, followed by the queasy silence as Hargreaves, stubborn once again, refused to respond to such an unjustified personal outrage. Lulubelle bawled, ignorant of motherly coos and clucks. The graze, gained in too enthusiastic a jump from the boat, focused the attention of all to her knee. Hargreaves came away. Cassius caught his eye.

Her architectural gift was particular. Across a long and roughly kept lawn was a small brick building. Twenty or so years ago now, Beryl's brothers had been found there, one cuddled to the other, both quite dead. It was in the building's recent transformation that the architect had found the limitations of her stepson. The building had been dark, too far recessed, with too few windows. Its depths collected dirt and decay. Her scheme, rather beautiful, was to cut the building in half, and to use the revealed joists in an ingenious way, to make a glazed wall. Cheap, striking and effective. "Firmenesse, commoditie and delight." She winced at the glibness of a phrase that buried months of thought. Cassius was the only one who spent any time there, and how much time. He gathered horseshoes. Avoiding the habit of nailing them to walls and doors, he had a fondness for their form. Their great size, their gainliness, their strength. He cherished their irresistible authority. They went where they went, all else accommodated them, yielded to them, or bruised. His own great hands and feet, almost uncontrollable then, had broken too many panes, wrenched too many timbers for his stepmother's concentrating satisfaction. They spoke very little now, and though the building was perfected, eventually, in all respects, and to that testing satis-

IAN KIAER *Salisbury Walk, Geese*

faction, she felt the project had been sullied. It was never after the simple, decisively elegant solution that she had dreamed. Cassius placed his own booted feet on the horseshoes. He let his fingers taste the marvellously crude indelicacy of the rusting iron. Sometimes he struck out with one, unexpectedly, to complete and convincing effect.

5.

Hargreaves and Cassius sat. The similarity of their physical demeanours sang out. The blow which killed Rafe, which laid such a deep, narrow dent in his skull, could hardly have been surprising. They had taken to arguing, and from playfully boisterous rowing, the undercurrents were starting to find themselves. Cassius realised, but could now lay his finger on the reasons for

his dislike of his brother. Rafe was deaf to the nuances, the doubling meanings, the exactingly maliciously way in which Cassius could articulate himself beyond the merely violent expulsions required by argument. His talent for exquisitely penetrating acidity, was lost on Rafe's easier way. But, the brilliance of the words were taking Cassius to places that he had not yet imagined. Fast-moving, agitated, scintillating, and not wholly unterrifying.

The blood on the grass, and the droplets on the leaves of the rose bush, left as Rafe reeled through the clear-aired afternoon light, were unsurprising. The way that the red sat against the communing greens, and struck up a conversation with the vividly darkened patch of sky, that would soon sunshower all away, with the promise of a rainbow; these things were so still. They were so precise, so very so. They seemed more than the artful accidents of rage. There seemed to be a measured purpose, an unfolding if mysterious logic. It was with this diagrammatic reality that things became unsurprising. It was unsurprising, for instance, when, too late to the scene, the engineer closed his giant hands on his youngest son's throat; and he looked distracted, as if he were thinking of something else, something higher. It was unsurprising that Hargreaves should have such a beatific smile, and that he should not struggle too much to breathe. It was unsurprising too, when the engineer held Cassius to him, and called him "Son," again. "Jump, said the mammy fish, we jump, said the few. Your new trousers and shirt, son. You'll need these clean. Go and speak to your mother."

6.

In his worn, dark, plain grey suit and his brown heavy brogues and thickly rumpled faun socks, with his great legs splayed, and in the middle of the lawn, some way in front of the rebuilt summer house, Till sat.

tony

i am a man of 38 looking 4 love please release me and
let me love again

W.riter

You need locking up Tony not releasing.

Amy Butterfield

Albino Girl

I am the albino girl!
my mother says I'm beautiful, but I know I'm not, I'm ugly.
I'm a wonderfully ugly mutant.
I just wish and wish to be a beautiful butterfly!
I'm a nightmare!
A nightmare with two sets of vivid violet eyes.
I Dream of the butterflies, I talk of the butterflies.
I am an albino butterfly with humungous ugly scales.
I am the ugly almost beautiful butterfly dreaming reptilian girl.

Acknowledgements

Thanks to all the Artists, Writers, Curators and Technicians who have been involved with the project at APT Gallery, The Mead Gallery, The Culture Company, Huddersfield Art Gallery, The Hatton Gallery and ARTicle Press. Particular thanks to Andrew Burton at the University of Newcastle and Sarah Shalgosky at the Mead Gallery. Thanks to Lucie Hernandez for her work on the website and to Kit Craig, Tim Greaves, Catherine Hemelryk, Phil Marsden and Maeve Polkinhorn.

www.infallible.org.uk

List of Plates